Fashion and Make-up of Edo Beauties Seen in *Ukiyo-e* Prints

The POLA Research Institute of Beauty & Culture Collection

Preface

As part of our research and study of make-up, hairstyles and personal adornments, the POLA Research Institute of Beauty & Culture has collected Japanese *ukiyo-e* woodblock prints that depict various aspects of the customs and ways of make-up in the Edo period (1600-1868). This book focuses on Edo-period *ukiyo-e* prints from our collection, and explains what kind of make-up, hairstyles and clothing women were using and wearing in the Edo period while also elucidating, in an easy-to-comprehend manner, the differences in social status, occupation, and way of life among women. These *ukiyo-e* not only reveal the different types of women depicted, together with the kinds of make-up, hairstyles and clothing that are associated with the female beauty, but also include peripheral things depicted incidentally, thereby providing valuable information. We hope readers will thoroughly enjoy this book.

Fashion and Make-up of Edo Beauties Seen in *Ukiyo-e* Prints

The POLA Research Institute of Beauty & Culture Collection

Table of Contents

Chapter 1

Ways and Customs of Make-up in the Edo Period

Make-up Scenes	18 *ukiyo-e*
Scenes of Hairdressing	8 *ukiyo-e*

Chapter 2

Fashion in the Edo Period

Courtesan Fashion	7 *ukiyo-e*
Fashion of Edo Women	5 *ukiyo-e*
Brides' Fashion	4 *ukiyo-e*

Notes by translator
An asterisk '*' indicates a translator's note.
Japanese names are given in the Japanese order: family name followed by given name.

Contents

Chapter 1
Ways and Customs of Make-up in the Edo Period

Make-up Scenes 18 *ukiyo-e*

Bien Senjokō
Bien Senjokō Keisai Eisen 10

Album of Paintings by Renowned Artists
Meihitsu ukiyo ekagami Gototei Kunisada 12

One Hundred Poems Each by a Different Poet, Likened to the Ogura Version: No. 60, Koshikibu no Naishi
Ogura gi hyakunin isshu, 60 ban, Koshikibu no Naishi Utagawa Toyokuni, on Commission 14

The Gijo (geisha/courtesan) Haruno Ashita
Gijo Haruno Ashita Kōchōrō Kunisada 16

Combination of Five Colors of the Floating World: White
Ukiyo goshiki awase, shiro Kunisada renamed Utagawa Toyokuni II, on Commision 18

Auspicious Desires of Land and Sea: Wanting to Improve one's Habits / Fishing for Bonito in Sagami Province
Sankai medetai zue, kuse ga naoshitai, Sōshū katsuo tsuri Ichiyūsai Kuniyoshi 20

Light Make-up of the Present Day
Tōsei usugeshō Gototei Kunisada 22

Modern Stories: Double Suicide of Sankatsu and Hanshichi
Tōsei michiyuki furi, Sankatsu Hanshichi Gototei Kunisada 24

Parody of the Six Poetry Immortals
Nazorae roku kasen Ichiyōsai Toyokuni 26

Forty-eight Techniques of the Floating World: The Technique of Staying Up Late and Sleeping in the Morning
Ukiyo shijūhatte, yo o fukashite asane no te Keisai Eisen 28

Modern Chrysanthemum Varieties: Hearing Good News in the Morning
Imayō kiku soroi, asa kara yoi koto o kiku Ichiyūsai Kuniyoshi 30

One Hundred Poems Each by a Different Poet, Likened to the Ogura Version: No. 48, Priest Egyō
Ogura gi hyakunin isshu, 48 ban, Egyō hōshi Kōchōrō Toyokuni 32

Fujibitai (Mt. Fuji-shaped forehead)
Fujibitai Keisai Eisen 34

A Scene of Courtesans at their Toilette
Kimitachi atsumari yosooi no zu Utagawa Toyokuni 36

Seven Episodes of Ono no Komachi and Customs of the East: Sōshi Arai
Nana Komachi Azuma fūzoku, sōshi aria Baichōrō Kunisada 40

Comparison of Fashionable Beauties
Ryūkō bijin awase Kōchōrō Kunisada 44

One Hundred Famous Places of Edo: Komagata-dō Hall and Azumabashi Bridge
Edo meisho hyakkei, Komagata-dō Azumabashi Utagawa Hiroshige 48

Fashionable Life-size Dolls: Kume no Sennin
Tōsei mitate ningyō no uchi, Kume no Sennin Ichiyūsai Kuniyoshi 50

Scenes of Hairdressing 8 *ukiyo-e*

Women's Customs
Fujin tashinami kusa Kōchōrō Kunisada 54

Pictorial Commentary of One Hundred Poems Each by a Different Poet: No. 78, Taikenmon-in Horikawa
Hyakunin isshu eshō, 78, Taikenmon-in Horikawa Kunisada renamed Utagawa Toyokuni II 56

Hauta Songs in a Book of Secrets
Hauta toranomaki Toyohara Kunichika 58

Pleasure of a Rainy Spring Evening
Harusame yutaka no yūbae Utagawa Toyokuni 60

Seven Fashionable Episodes of Ono no Komachi: Seki-dera Komachi, the Courtesan Ōyodo of the Tsuru-ya House
Fūryū nana Komachi, Seki-dera Komachi, Tsuru-ya nai Ōyodo Kikukawa Eizan 64

Forty-eight Habits of the Floating World: Those Who Want Everything Are Carefree
Ukiyo shijūhachi kuse, nandemo hoshigaru wa ku nashi no kuse Keisai Eisen 66

Index of Representative Proverbs: He, Seashore
Tatoegusa oshie hayabiki, he, hotori Chōōrō Kuniyoshi 68

Various Women of the Floating World, Second Series
Ukiyo meijo zue, nihen Gototei Kunisada 70

Contents

Chapter 2

Fashion in the Edo Period

Courtesan Fashion 7 *ukiyo-e*

The Courtesan Otaka of Maruebi-ya House, Views of Mt. Fuji from Various Provinces, a View from the Capital
Maruebi-ya nai Otaka, shokoku Fuji zukushi, miyako no Fuji — Ippitsuan Eisen — 74

An Excellent Selection of Thirty-six Noted Courtesans: The Story of Tamagiku
Meigi sanjūroku kasen Tamagiku no hanashi — Utagawa Toyokuni, on Commission — 76

The Courtesans Asazuma, Hanamurasaki, and Tagasode of Tama-ya House in Edochō, Shin-Yoshiwara
Shin-Yoshiwara Edochō, Tama-ya nai Asazuma Hanamurasaki Tagasode — Utagawa Toyokuni — 78

Biographies of Famous Women, Ancient and Modern: Hakidame Omatsu
Kokon meifuden, Hakidame Omatsu — Utagawa Toyokuni — 82

The Twelve Hours of Spring Pleasures: Hour of the Tiger
Haru asobi jūni toki, tora no koku — Utagawa Toyokuni — 84

Sixty-nine Stations on the Kisokaidō Road: Ageo, the Courtesan Takao of the Miura House
Kisokaidō rokujūkyū tsugi no uchi, Ageo, Miura no Takao — Ichiyūsai Kuniyoshi — 86

Scene of Lord Yorikane Redeeming the Contract of the Courtesan Takao of the Miura-ya House in Shin-Yoshiwara
Shin-Yoshiwara Miura-ya no Takao, Yorikane gimi miuke no zu — Nagashima Mōsai — 88

Fashion of Edo Women 5 *ukiyo-e*

Twelve Scenes of Modern Beauties: Tōeizan Kan'ei-ji Temple, Looking Pleased
Imayō bijin jūni kei, Tōeizan Kan'ei-ji, ureshisō — Keisai Eisen — 92

Flower Garden of the Four Seasons at Okuyama, Asakusa, Part III: Panoramic View of Plum-blossom Viewing
Asakusa Okuyama shiki hanazono kanbai enkei, sono san — Utagawa Toyokuni — 94

Modern Tale of Genji Picture Scrolls: Washing
Genji imayō emaki, arai — Utagawa Kunisada — 98

The First Day of the Hare Festival at Kameido
Kameido hatsuu matsuri — Utagawa Toyokuni — 102

Modern Chrysanthemum Varieties: Drinker
Imayō kiku soroi, hidari ga kiku — Ichiyūsai Kuniyoshi — 106

Brides' Fashion 4 *ukiyo-e*

Three Rites: Wedding Scene
Santeirei no uchi, konrei no zu Ichiyūsai Kuniyoshi 108

Wedding Scene in Genji-style Painting
Genji goshūgen no zu Utagawa Toyokuni 112

Etiquette for Women: Wedding
Fujin shorei kagami no uchi, konrei Ichiyūsai Kuniyoshi 116

Scene of Bride's Change of Dress
Konrei ironaoshi no zu Ichiyūsai Kuniyoshi 120

Chapter 1

Ways and Customs of Make-up in the Edo Period

Make-up Scenes 18 *ukiyo-e*

Scenes of Hairdressing 8 *ukiyo-e*

Make-up in the Edo Period

One of the joys of looking at *ukiyo-e* is that each print provides us with much information through a variety of things depicted in them – in other words, we can interpret the picture. This section introduces what kind of make-up was worn by *ukiyo-e* beauties in the Edo period, while also showing scenes of make-up using white face powder and rouge, as well as scenes of tooth-blackening, face washing and hairstyling, mostly during the second half of the Edo period. We shall also look at what kind of cosmetics and cosmetic accessories were used by women of the time.

Bien Senjokō

Bien Senjokō

美艶仙女香

Keisai Eisen
渓斎英泉

Bunka 12 – Tenpō 13 (1815-42)
文化 12 年～天保 13 年

A beautiful woman and the Bien Senjokō brand of white powder

Having a short forelock with a large *tsubushi*-Shimada* hairstyle, this young woman must be a geisha. She is wearing lip rouge called *sasairo-beni* (lit. rouge in bamboo-leaf color). Made from safflower, this rouge would look green if thickly applied, and was popular around the Bunka and Bunsei eras (1804-30). In her right hand, she holds a hand-mirror with a *nandina* plant design while, with her left hand, she applies white powder to her face using a brush inscribed Shikibu (志きぶ). There is mention of Shikibu in the book *Naniwa hyakujidan* (Encyclopedia of Nania), indicating that a long-established brush store, called Fukuoka Shikibu in Yamashiro province (the southern part of present-day Kyoto prefecture), made good quality brushes for white powder in Naniwa (present-day Osaka), and became famous throughout the country.

Bien Senjokō white face powder is depicted in the inset in the upper right-hand corner. Senjokō was named after Senjo, the haiku pen-name of Segawa Kikunojō who, active around the Kansei era (1789-1801), was a great actor of female Kabuki roles. Senjokō powder was sold by Sakamoto at Inari Shinmichi, 3-chōme, Minami-denmachō, Kyōbashi, Edo. This *ukiyo-e* was most likely a link between Sakamoto and the publisher. Bien Senjokō was popular from around the Bunsei (1818-30) to the Tenpō eras (1830-43), and 40 *ukiyo-e* have been identified depicting it. The inscription to the left of the inset is a text on Bien Senjokō by Tōzai-an Nanboku. It is worth mentioning that Tōzai-an Nanboku, widely known as Asakura Rikizō, was a writer of popular literature, a woodblock carver, and also a designer of *ukiyo-e*. He was, as we would say, a *maruchitarento* ('multi-talented person') in modern Japanese.

The geisha depicted here wears *kanzashi* (hairpins) decorated with chrysanthemums on both sides of her head and at the front. Her kimono bears the crest of *yaeura-sakura* (the underside of double cherry blossoms), and her *obi* (sash) reveals a quince design. This *ukiyo-e* reflects a time when a fair complexion was a prerequisite for a beautiful woman. For this reason it was part of a geisha's work to apply white powder meticulously, thereby making her skin look fair. This, in turn, would make her look sophisticated and chic or, as we would say in Japanese, *iki* or *ada*.

* Shimada-style hair consists of a topknot tied in the middle with a *motoyui* (paper string) or *takenaga* (paper strip), hence the topknot has upper and lower parts. *Tsubushi-Shimada* is one of its variants, with the upper half of the knot pressed forward and somewhat flattened.

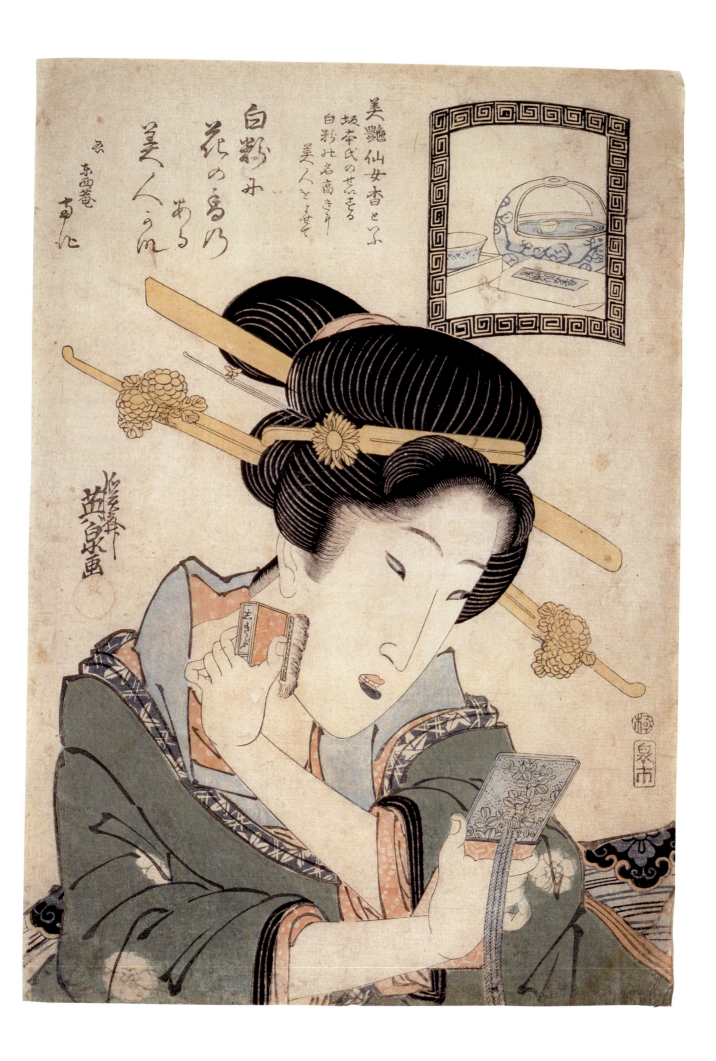

Album of Paintings by Renowned Artists
Meihitsu ukiyo ekagami

名筆浮世絵鑑

Gototei Kunisada
五渡亭国貞

ca. Bunsei era (1818-30)
文政頃

Drawing the eyebrows

With a *tenugui* (hand cloth made of cotton) on her left shoulder and, with her elbow on the dressing table, this woman is probably a young *yūjo* (courtesan). As we see a box pillow and *futon* mattress, she is likely at her toilette after a sleep. Because she is young, her hair ornaments are truly flamboyant – a *ryōten-kanzashi* (hairpin with a pair of ornaments at either ends) inserted into a *yuiwata*-hairstyle (a kind of Shimada style), bound with *motoyui* (paper strings for tying the hair), and a large ribbon for the front part of her hair. Her eyes look serious, staring at the shape of her eyebrows in the mirror, probably considering the balance of the left and right brows, as even just a brow could change the appearance of the entire face.

Eyebrow ink is depicted near her elbow. In the Edo period, it was made from soot, smutted wheat, peeled and charred hemp stem, as well as *makomo* (wild rice that grows in large clusters in marshy fields).

If we look closely at the dressing table, a drawer is pulled out to her right. This is because, if the drawer pulled out towards her, it would prevent her face from getting close to the mirror. Inside the dressing table is something that looks like looped *motoyui* while, next to the stand is an *ugai-chawan* (cup for gargling or rinsing the mouth); here again, Bien Senjokō white powder is casually placed.

The kimono she is wearing depicts bamboo, cherry blossoms, and horses, while her inner kimono is decorated with a geometric *uroko* (lit. fish scale) pattern.

The hanging scroll behind her depicts a courtesan painted by the *ukiyo-e* artist Tanchōsai Okumura Bunkado Masanobu (1686-1764), probably in or after the Kyōhō era (1716-36). Both the characteristic curled-up hair at the back of her head and the style of dressing make it possible to date the painting.

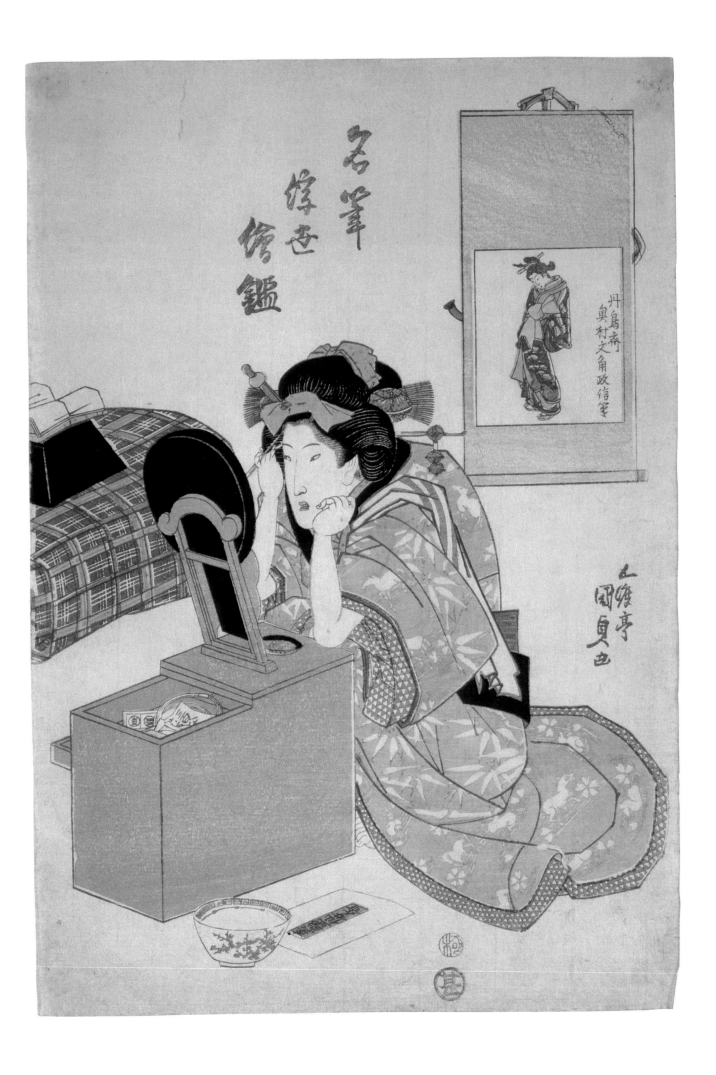

One Hundred Poems Each by a Different Poet, Likened to the Ogura Version: No. 60, Koshikibu no Naishi
Ogura gi hyakunin isshu, 60 ban, Koshikibu no Naishi

小倉擬百人一首　六十番　小式部内侍

Utagawa Toyokuni, on Commission
応需　歌川豊国

Kōka 4 (1847)
弘化 4 年

Candlelight and Make-up

This *One Hundred Poems Each by a Different Poet, Likened to the Ogura Version* is a series of 100 prints collaboratively designed by Toyokuni, Kuniyoshi and Hiroshige. The upper part of the print includes the poem with an illustration from *Ogura hyakunin isshu* (The Ogura Version of the One Hundred Poems Each by a Different Poet) with an explanatory text on the poem. This series was much talked about as being produced by the three great masters of the day.

Hyakunin isshu is a selection of 100 *waka* poems each by a different poet, particularly those privately selected at Mt. Ogura, Kyoto, by Fujiwara Teika who was active in the late Heian (794-1185) and early Kamakura periods (1185-1333), known as *Ogura hyakunin isshu*. The 100 poets chosen in the Ogura version consisted of 79 men and 21 women. Among the men, seven were emperors, one was a prince, 28 were court nobles, 28 were lower-rank nobles, 12 monks, and three were unknown. As for the women, one was an empress, one a princess, 12 were court ladies, and two were mothers of court nobles.

In this *ukiyo-e* print, Koshikibu no Naishi was the daughter of Tachibana no Michisada, while her mother was Izumi Shikibu. Koshikibu no Naishi served the Empress Chūgū Jōtōmon-in, wife of the Emperor Ichijō. Her poem selected here, composed when her mother had gone to Tango province (present-day northern part of Kyoto prefecture), reads "Ōe-yama, ikuno no michi no tookereba mada fumi mo mizu ama no hashidate (How could my mother / help me write this poem? / I have neither been / to Ōe Mountain nor Ikuno / nor have any letters / come from her / in a place so far away it's called– / The Bridge to Heaven.)*." It is not clear, however, what was the connection between the poem and the woman likely to be a courtesan, applying her eyebrow make-up in front of the dressing table.

The courtesan is wearing a kimono with a bamboo design, though this may be a dressing-gown since we can see a kimono with a stylish design of an arrowhead plant behind her. Apart from this, what is interesting about this *ukiyo-e* is the candle fixed on top of the mirror-case. This shows that, back then, people went to great lengths to obtain light. The height is ideal for make-up, since it allows the face to be well lit. A similar device can be observed on dressing tables used by actors. This combination of mirror-case and table is somewhat unusual in that the former is decorated with a *toshidama* motif on a black ground, which also served as the crest of the Utagawa school, while the latter depicts a maple design, suggesting that they do not form a set. Although the mirror-case and dressing table are usually of the same design, it is possible that Toyokuni deliberately drew his own crest on the mirror-case.

In this print, the impact of the candle is more significant than the application of make-up.

* McMillan, Peter, *One Hundred Poets, One Poem Each: A Translation of the Ogura Hyakunin Isshu*, Columbia University Press, 2008.

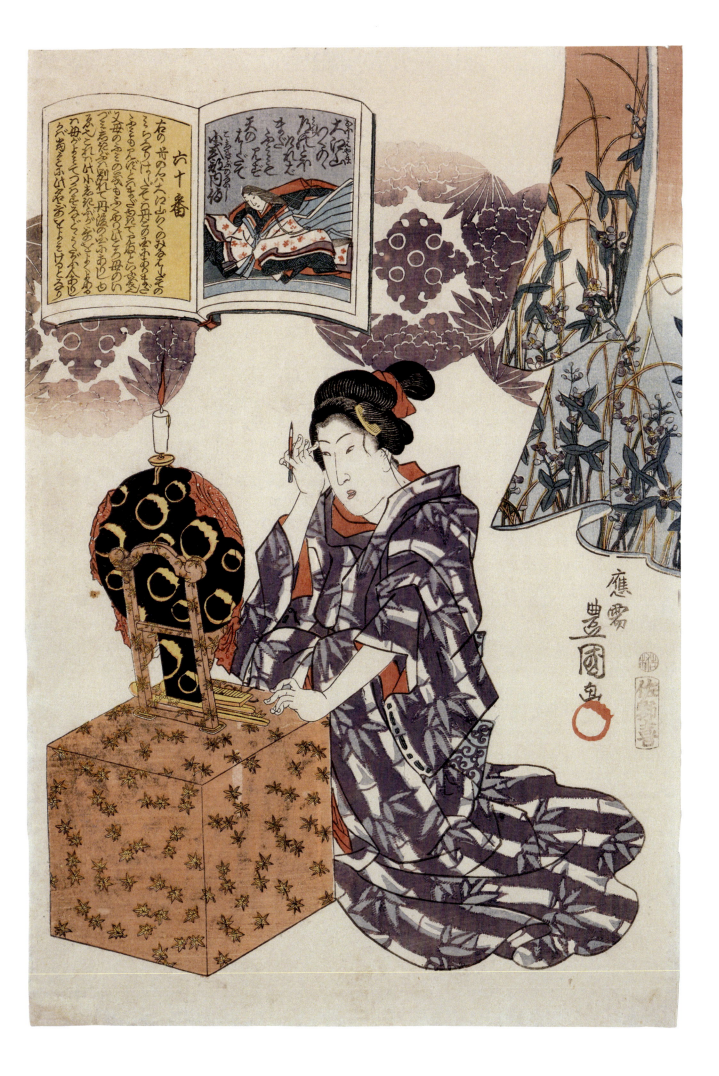

The Gijo (geisha/courtesan) Haruno Ashita
Gijo Haruno Ashita

妓女春のあした

Kōchōrō Kunisada
香蝶楼国貞

ca. Bunsei era (1818-30)
文政頃

New Year's Make-up

This is the central sheet of a triptych. It depicts an Adonis plant on the right shelf, a *mochibana,* which is a hanging decoration with *koban* (oval gold coins) and cocoon-shaped rice cakes, as well as a *bonsai* plum-tree. This is probably a New Year scene inside a brothel. Although we do not have the other two sheets, our research suggests that the left-hand side depicts someone who appears to be the mistress of the brothel wearing an inner kimono with a snowflake design, while the right-hand sheet portrays a woman, apparently a geisha, changing into a kimono with a pattern of cranes and turtles.

The woman at the dressing table in this print has her hair in a *tsubushi*-Shimada style, into which a long *kōgai* (hair stick), *kushi* (comb), and *kanzashi* (hairpins) that look like tortoiseshell are inserted. She is turning her face, probably talking to a geisha on her left. Her red kimono is decorated with a bat design (in China the bat is favored as a symbol of longevity as well as an auspicious motif, since the second character that makes up the word 'bat' 蝙蝠 is a homonym for happiness (福), thereby achieving popularity in Japan from the second half of the Edo period); the kimono borders and hem which depict cranes on a striped ground are in the style of *gakubuchi-jitate*. The woman seems ready to apply her make-up, having Bien Senjokō white powder beside the dressing table, on which an *ugai-chawan* is placed, while such things as paper strings for tying the hair can be seen in the drawer. It is very likely she will be off to work after finishing her make-up.

She is a *gijo**, and may be a geisha rather than a courtesan. The brothel is closed on New Year's Day, and the following day is the first working day of the year. It marks the beginning of busy days for her, just as for others.

* The Japanese word *gijo* refers to both geisha and courtesans.

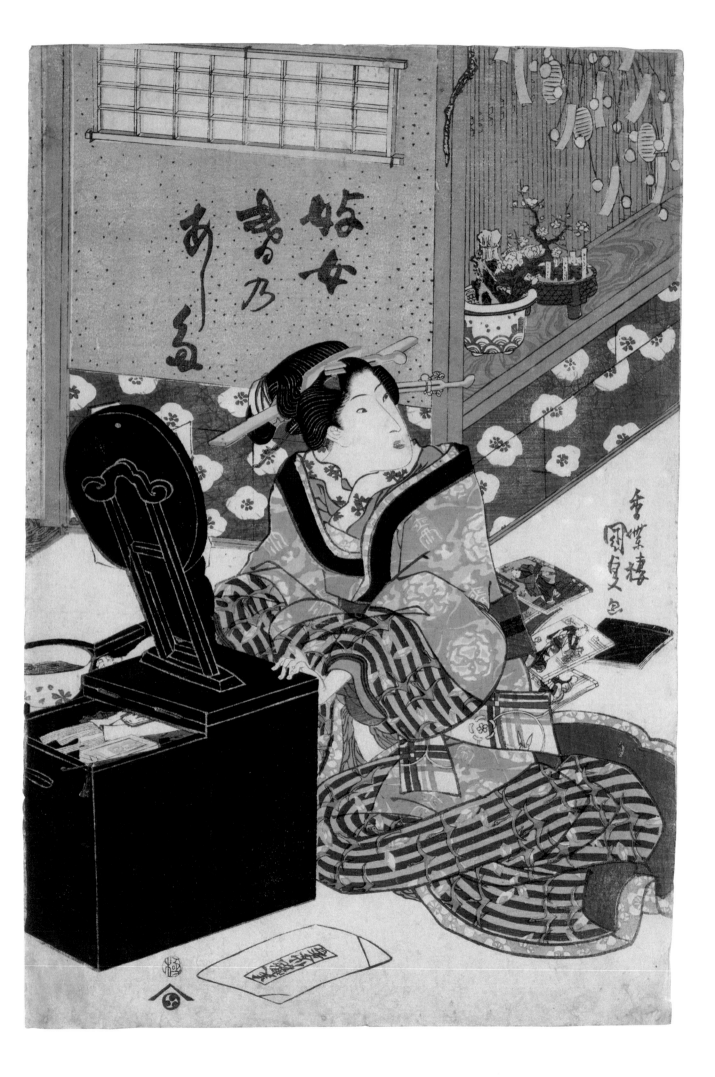

Combination of Five Colors of the Floating World: White
Ukiyo goshiki awase, shiro

浮世五色合　白

Kunisada renamed Utagawa Toyokuni II, on Commision
応需　国貞改二代歌川豊国

Kōka 4 (1847)
弘化 4 年

Fair complexion and the white color of face powder

　This *Combination of Five Colors of the Floating World: White* is one of five portraits of beautiful women in this series. Unfortunately we have only this 'white' one, while the other colors are red, yellow, black and blue. The print representing red depicts a woman cooking a red-fleshed fish while that for yellow, by an adult woman holding a tortoiseshell hairpin in her hands. The print referring to black depicts a woman practicing calligraphy with a child, and blue is portrayed by a young girl with a bamboo branch from which hangs a paper bird. In this example representing 'white', Rakutei Saiba writes about a variety of white items, such as white rice, sweet white sake, fair (white) complexion, white chrysanthemums, and white face powder. (He was a writer of popular literature in the second half of the Edo period, who was the son of Nishimiya Sinroku, a publisher in Edo and follower of Shikitei Sanba.) Since white face powder was particularly suitable for depicting a beauty, and probably also because the artist liked the composition of a woman looking at the nape of her neck in two mirrors facing each other, Kunisada produced a number of *ukiyo-e* with a similar composition, including *Imafū keshō kagami* (*Contemporary Make-up Mirror*) and *Tōsei bijin awase, mijimai geisha* (*Contest of Contemporary Beauties: Geisha at her Toilette*), at the time he used the pseudonym Gototei Kunisada (1807-27).

　A young woman, probably a geisha, with a *tsubushi*-Shimada hairstyle and a red *tegara* (decorative cloth), entirely fills the print. Whereas her undergarments reveal a design of herons and waves, as well as a pattern of cherry blossoms and hemp leaves, her kimono is somewhat restrained. Her *obi* is a combination of various patterns.

　In the Edo period, face powder was usually made of lead, with white being the only color available. The white face powder was mixed with water and applied with a brush or the hand to the face and neck to around as low as the chest, as well as to the nape of the neck. Because it is hard to see the nape, the woman is carefully checking to see if it has been properly applied. The text by Rakutei Saiba includes words related to make-up, such as "a fair complexion hides seven flaws… To correct the nape, light make-up with a bit of white powder…" In short, he probably meant that a fair complexion with light make-up was a prerequisite for a beauty.

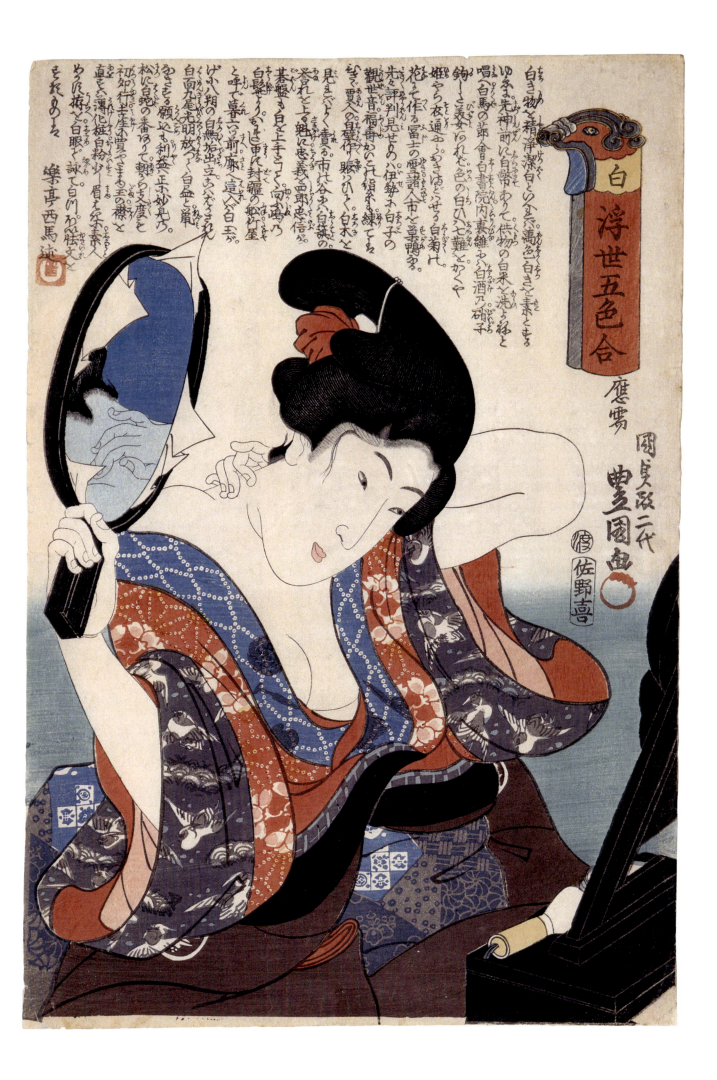

Auspicious Desires of Land and Sea: Wanting to Improve one's Habits / Fishing for Bonito in Sagami Province

Sankai medetai zue, kuse ga naoshitai, Sōshū katsuo tsuri

山海目出多以図会　くせが直したい　相州鰹魚釣

Ichiyūsai Kuniyoshi
一勇斎国芳

Kaei 5 (1852)
嘉永5年

Patchiri white powder for the nape of the neck

The word Sōshū in the inset Sōshū *katsuo tsuri* refers to Sagami province (most of present-day Kanagawa prefecture). "*Katsuo* (bonito) of Sagami province" is referred to in the books *Wakan sansai zue* (Illustrated Sino-Japanese encyclopedia) and *Kefukigusa* (Textbook on haiku and *renga* poems) as an example of specialties of various provinces. In Japan bonito is found in large numbers in the Pacific Ocean. As a seasonal migratory fish, bonito goes north in spring along the *kuroshio* (the Japanese Current), and south in autumn. In the Edo period, the first bonito of the year was referred to as *hatsugatsuo* and was highly valued as a sign of the arrival of summer.

The bonito of Sagami province was probably well-known because it was transferred to Edo from Kamakura, Odawara, or neighboring areas by horses or boats. Kuniyoshi depicted the bonito of Sagami in another print *Sankai meisan zukushi Sagami no katsuo* (*Various Specialties of Mountains and Seas: Bonito of Sagami*).

The young woman portrayed by Kuniyoshi is looking at a mirror reflected in another. Since her chest is scantily covered, she may be checking how well the white paint has been applied around her neck. In the bottom left is a package of white powder bearing the inscription 'Eri oshiro[?]* Hatchi[?] Denmachō itchōme Tsutaya Kichiya (White powder for the nape, Hatchi Denmachō 1-chōme Tsutaya Kichiya, 御えりおしろ□　はつち□傳馬町一丁目津多や吉也)'. The Hatchi probably refers to Patchiri *oshiroi* (Patchiri-brand white powder) for the neck. The shop, Tsutaya in Denmachō, is not listed in the shopping guidebook *Edo kaimono hitori annai*, published in Bunsei 7 (1824). This suggests that it was not a well-established shop.

The woman's hair is in the *tsubushi*-Shimada style with a red cloth tied around the knot. Her cropped forelock curving towards the sides is evidence that she is young. Her kimono depicts butterflies on a white ground, while the *obi* is of top-quality Hakata weave, imparting a sense of early summer. Although the link between the white-painted neck and the title 'Wanting to improve one's habit' is not clear, the latter may be the words she murmured to the mirror. It makes us want to ask her what the habit is.

* The question mark in square brackets indicates the place where there is an illegible character.

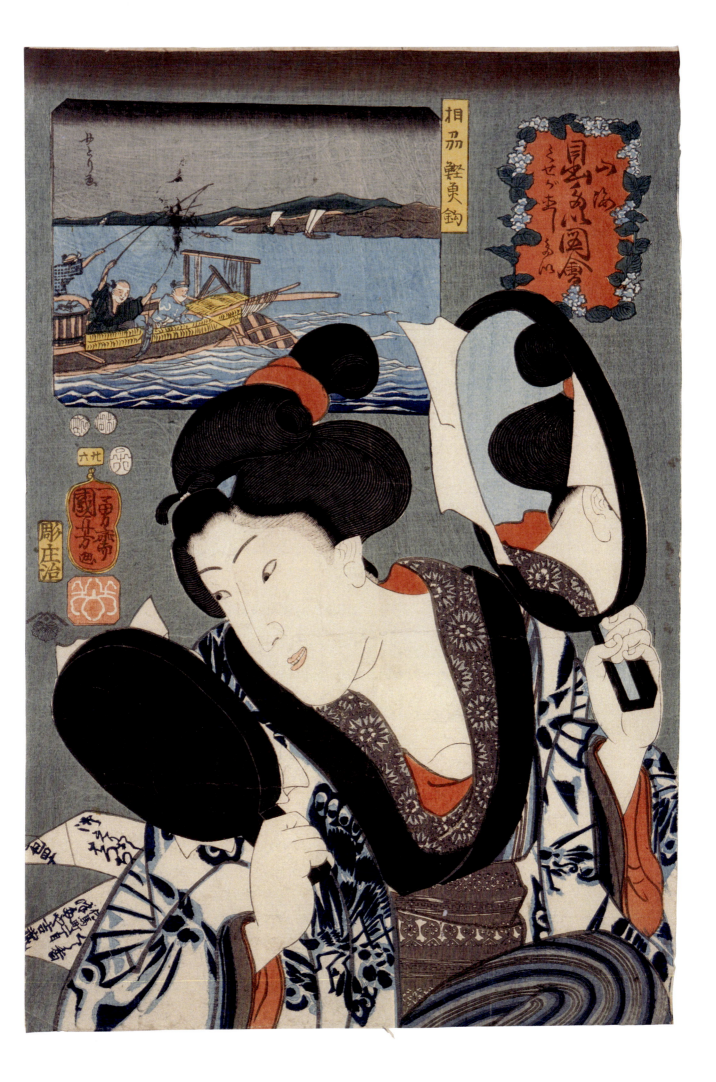

Chapter 1　Ways and Customs of Make-up in the Edo Period　Make-up Scenes

Light Make-up of the Present Day
Tōsei usugeshō

当世薄化粧

Gototei Kunisada
五渡亭国貞

ca. Bunsei era (1818-30)
文政頃

Fashionable light make-up

The title box on the right reads *tōsei* (lit. contemporary, 当世), while in some prints it is also written as 時世. It may be that 時世 was read as *imayō* or *tōsei*. Either 当世 or 時世 is inscribed in the *toshidama* emblem of the Utagawa school.

This series seems to depict Kabuki actors of female roles, such as geisha, nannies, mistresses, and young male prostitutes. The woman here does not appear to be a geisha but is possibly a courtesan. Behind her is a *tenugui* with an auspicious motif of bats and a pillow screen.

Does the title *Tōsei usugeshō* (*Light Make-up of the Present Day*) refer to fashionable make-up of the second half of the Edo period? Generally speaking light, natural make-up was favored more in Edo than in Kyoto and Osaka. Shikitei Sanba wrote in his novel *Ukiyoburo* (*Ukiyo* bath) published in 1809-1813, that a woman too heavily made-up looked lecherous, gaudy, and indecent, while light make-up was neat and good, regarded as chic in various matters. Although there were women at that time who wore heavy make-up even in Edo, the passage suggests that light make-up was preferable.

This woman's kimono, with a design of bullfinch carvings of Usokae (the Bullfinch Exchange Rite), is slightly open at the front while her *obi* is also coming loose. She holds a mirror in its case in her right hand, checking her make-up and stray hairs of her *tenjin-mage** knots. She also holds a *kaishi* (tissue paper) in her mouth. The box lying on its side is probably a tobacco tray while, on the left, is a container for glowing charcoal and an ashtray. It is difficult to tell from the *ukiyo-e* whether her make-up is heavy or light.

* *Tenjin-mage* is a hairstyle with two loop-like topknots just as in an *ichōgaeshi* hairstyle, and a hairpin is inserted into the root of the topknot to which the end of the hair is coiled.

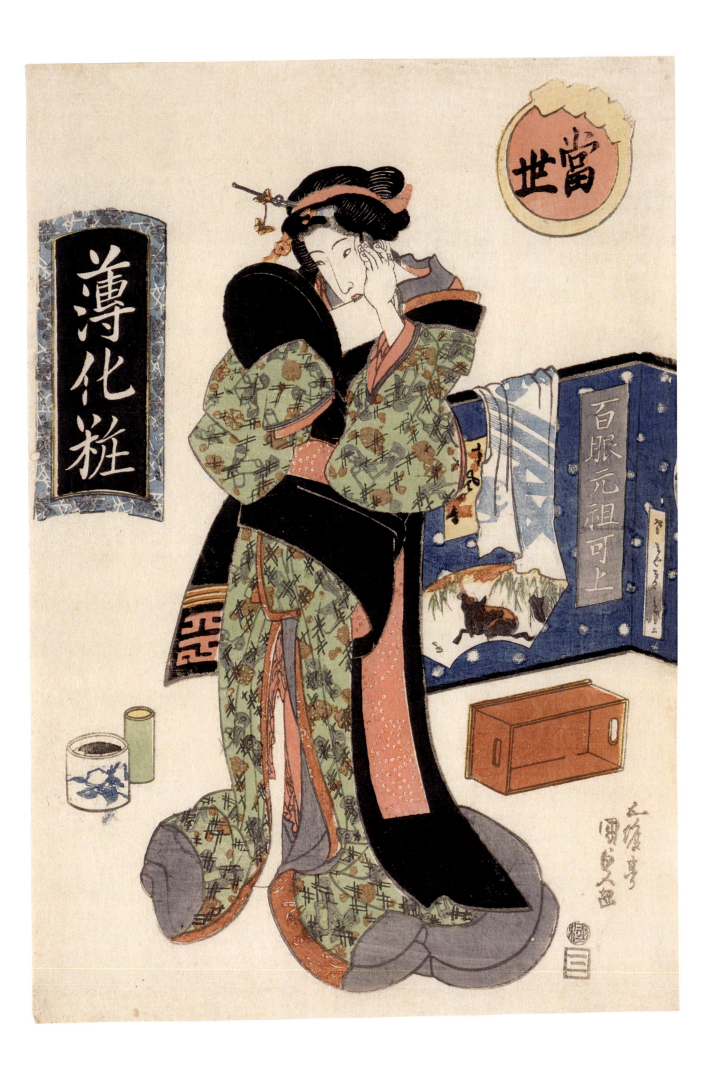

Modern Stories: Double Suicide of Sankatsu and Hanshichi
Tōsei michiyuki furi, Sankatsu Hanshichi

当世道行ふり　三かつ半七

Gototei Kunisada
五渡亭国貞

ca. Bunka 8 – late Tenpō era (1811-1844)
文化 8 年頃～天保末頃

A lovers' suicide drama and a make-up scene

This print, designed by Kunisada during the period he used the name Gototei, forms part of a series in which motifs were taken from *Kyōgen* plays with suicide stories of lovers. The print features the double suicide of Sankatsu (Minoya Sankatsu, a woman of Shimanouchi, Osaka, who cleaned bodies) and Hanshichi (Akaneya Hanshichi of Gojō Shinmachi, Yamato province (part of present-day Nara prefecture)), in the graveyard of Sennichi-dera temple in Genroku 8 (1659). In this print Sankatsu is depicted as a geisha, shaving her face with a razor.

Dressed in her *yukata* (bath robe or summer garment) with a design of pine needles and butterflies, she sits with one knee drawn up to her chest. Her hair is in the *tenjin-mage* style. The reason she is shaving may be that it was then easier to apply face make-up. On the dressing table are a razor box, hairpin, bowl filled with water and a *yokogushi* (comb to be inserted in the side hair). In the dressing table, tufted toothpicks smudged with rouge and a tooth-powder box are haphazardly placed. The drawer, slightly open, reveals *kesujitate* (narrow comb with a long pointed handle for parting the hair) and a *tokikushi* (wide-toothed comb).

Most dressing table-drawers of the Edo period open to the right rather than towards the user, allowing the viewer's face to be closer to the mirror. The box near the dressing table may be for *takenaga* (paper strips for tying a topknot) and hairpins, while an *ugai-chawan* can also be seen. On the other side of the table, Bien Senjokō-brand white powder is casually placed on the mirror-case. Although it is difficult to link the motif of the lovers' suicide with this make-up scene, the razor in her hand provides a somewhat vivid clue.

The inset seems to depict the roof of a playhouse; this may have something to do with the fact that the story of Sankatsu and Hanshichi was taken up as a subject in *Jōruri* puppet shows and Kabuki plays.

Parody of the Six Poetry Immortals
Nazorae roku kasen

模擬六佳撰

Ichiyōsai Toyokuni
一陽斎豊国

Kaei 1 (1848)
嘉永元年

Lip rouge and Ono no Komachi

This woman with freshly washed hair has an apron with a cherry-petal design over her shoulder. Is she a courtesan? She holds a coral-bead hairpin in her right hand and a cup containing lip rouge in her left.

The inset on the left depicts safflower and Ono no Komachi with the text of her poem from the anthology *Kokin wakashū* (The collection of old and new Japanese poetry) "Iro miede utsurou mono wa yo no naka no hito no kokoro no hana ni zo arikeru" (So much I have learned: / the blossom that fades away, / its color unseen, / is the flower in the heart / of one who lives in this world.)*. On the right is a text by Ryūkatei Tanekazu, a follower of Ryūtei Tanehiko. The text relates to rouge and 'Komachi praying for rain' from one of the seven episodes of Ono no Komachi, in which Komachi successfully caused it to rain heavily by composing a poem as a prayer for rain. The text hints at 'Komachi Rouge' named after Ono no Komachi, her name being synonymous with a beautiful woman.

Rouge in the Edo period was chiefly made from safflower. This type of rouge is depicted inside the *benichoko* (rouge cup). *Benichoko* does not normally have a lid, which would be placed upside down to prevent the color deteriorating over time. At that time, since only a small amount of rouge could be extracted from safflower, rouge was so expensive that it was said to be as precious as gold. Rouge of the Komachi brand was particularly famous, most likely as it reminded people of the beautiful Komachi. In order to make full use of it, people applied rouge to a small part of each lip rather than the whole surface. During the time when very few colors were available for make-up, rouge was an important cosmetic to emphasize femininity and exquisiteness.

* McCullough, Helen Craig, *Kokin Wakashū: The First Imperial Anthology of Japanese Poetry*, Stanford University Press, 1985

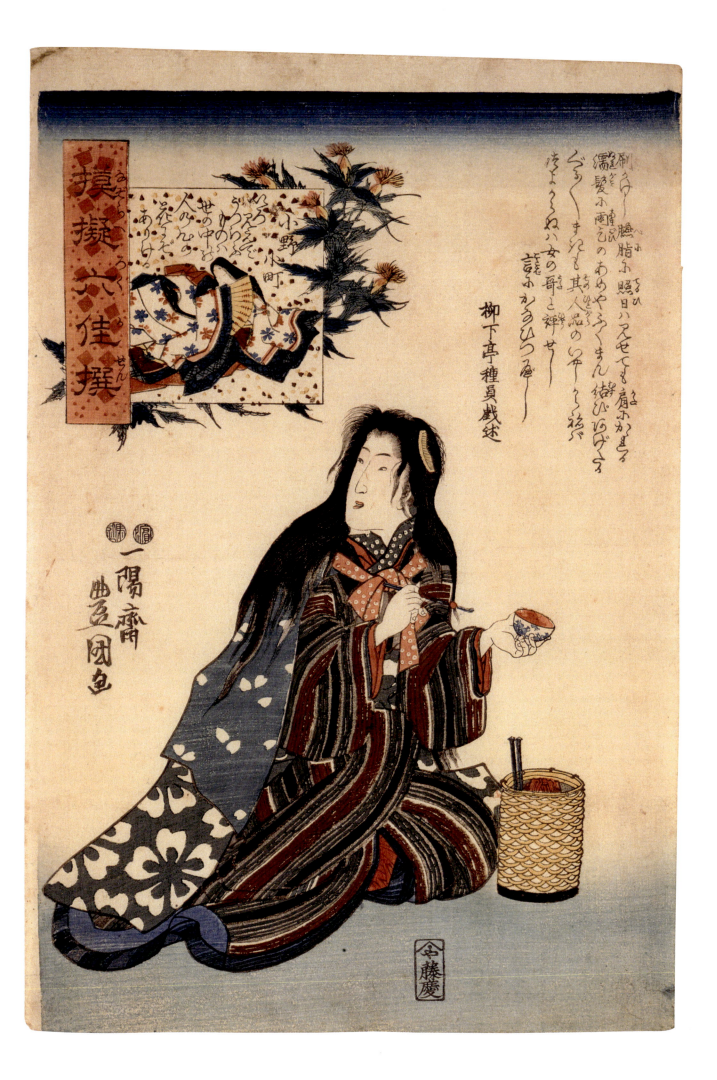

Forty-eight Techniques of the Floating World: The Technique of Staying Up Late and Sleeping in the Morning
Ukiyo shijūhatte, yo o fukashite asane no te

浮世四十八手　夜をふかして朝寝の手

Keisai Eisen
渓斎英泉

ca. Bunsei 4-5 (1821-22)
文政 4 〜 5 年頃

Tooth-brushing and *sasairo-beni* (lit. lip rouge in bamboo-leaf color)

The expression '*yo o fukashi te asane no te*' in the Japanese original title means getting up late in the morning. The woman on the left is the one to whom this can be applied. Wearing a Benkei-check kimono and a *tenugui* around her shoulders, she is yet to start her toilette. She is about to brush her teeth using a long tufted toothpick and tooth powder containing rouge. Her hairstyle is that known as *daruma gaeshi*, which is not an elegant style but one still found among women of mature years or those of the pleasure quarters.

With a *tsubushi*-Shimada hairstyle and a pot of morning glory in her hand, the young woman on the right has already carried out her toilette and finished dressing, and is briskly going about her work. It is worth noting that her lower lip is green in color. She is wearing *sasairo-beni* (lip rouge in bamboo-leaf color) which was enormously popular around the Bunka and Bunsei eras (1804-30).

Rouge in the Edo period was mainly made from safflower, and the amount of rouge extracted from it was so small, that it was very expensive and considered to be as precious as gold. This expensive rouge would look green if thickly applied, hence the name *sasairo-beni*. This fashion is said to have derived from the ostentatious use of a large amount of such costly rouge by courtesans, this often being depicted by Keisai Eisen and Utagawa Kunisada.

The woman on the right is wearing a kimono with a pattern of maple leaves and stripes, revealing its red lining at the collar. The morning glory is still in flower, suggesting that it is morning.

It is also worth noting that the *shijūhatte* (lit. 48 hands) in the title refers to various methods and ways in each area of activity.

Modern Chrysanthemum Varieties: Hearing Good News in the Morning

Imayō kiku soroi, asa kara yoi koto o kiku

時世粧菊揃　あさからよいことをきく

Ichiyūsai Kuniyoshi
一勇斎国芳

Kōka 4 (1847)
弘化 4 年

Tenugui (hand cloth made of cotton) and *nukabukuro* (rice-bran bag)*

This woman, who may be a courtesan, is wiping her hands on a *tenugui* with a tie-dyed pattern of Japanese abacus beads, also with a reddish rice-bran bag attached. This is probably a morning scene, as we can make out a tufted toothpick, an *ugai-chawan*, together with a box for tooth powder and tufted toothpicks at her feet.

As far as our research shows, this series *Modern Chrysanthemum Varieties* by Kuniyoshi comprises at least 16 works, including 'Taking an order for hot sake (*okan o kiku*)', 'Listening to news (*shirase o kiku*)', 'Granting a request (*nekahi (negai) o kiku*)', 'Drinker (*hidari ga kiku*)', 'Taking an order (*chiumon (chūmon) o kiku*)', 'Asking for directions (*michi o kiku*)', 'Asking whether she has a child (*kodomo ga aru ka to kiku*)', 'Definitely hearing it (*kitto kiku*)', 'Asking "Does it suit me?" (*niau ka to kiku*)', 'Asking how things are going (*yōsu o kiku*)', 'Quick-witted (*kiten ga kiku*)', 'Hearing good news in the morning (*asa kara yoi koto o kiku*)', and 'Listening to fortune-telling (*tsujiura o kiku*)'.

The woman is wearing a kimono with restrained vertical stripes, as well as an *obi* with a tie-dyed flower-wheel pattern and *manji-tsunagi* (interlocking swastika) with chrysanthemum motifs in red. Since she has just got up in the morning, her hair is untidy but still noticeably in the Shimada-*mage* style. As her teeth are not blackened, she is probably young; she also looks somewhat jolly and is smiling.

The inscription on the left is a text by Hōjutei Funauta (宝珠亭舟唄). Hōjutei may have been a comic poet, who contributed a poem to another *ukiyo-e* by Kuniyoshi. Incidentally, the collar of the kimono in this print reveals the character *hō* (宝), the same character as in Hōjutei (宝珠亭). Among the various women depicted by Kuniyoshi, those in this series are very interesting with intense facial expressions, something which cannot be observed in works by Eisen or Kunisada.

* *Nukabukuro* is a small bag containing rice bran. It is soaked in lukewarm water and squeezed, then gently rubbed over the face and body. It was a body cleanser that was also effective in moistening the skin.

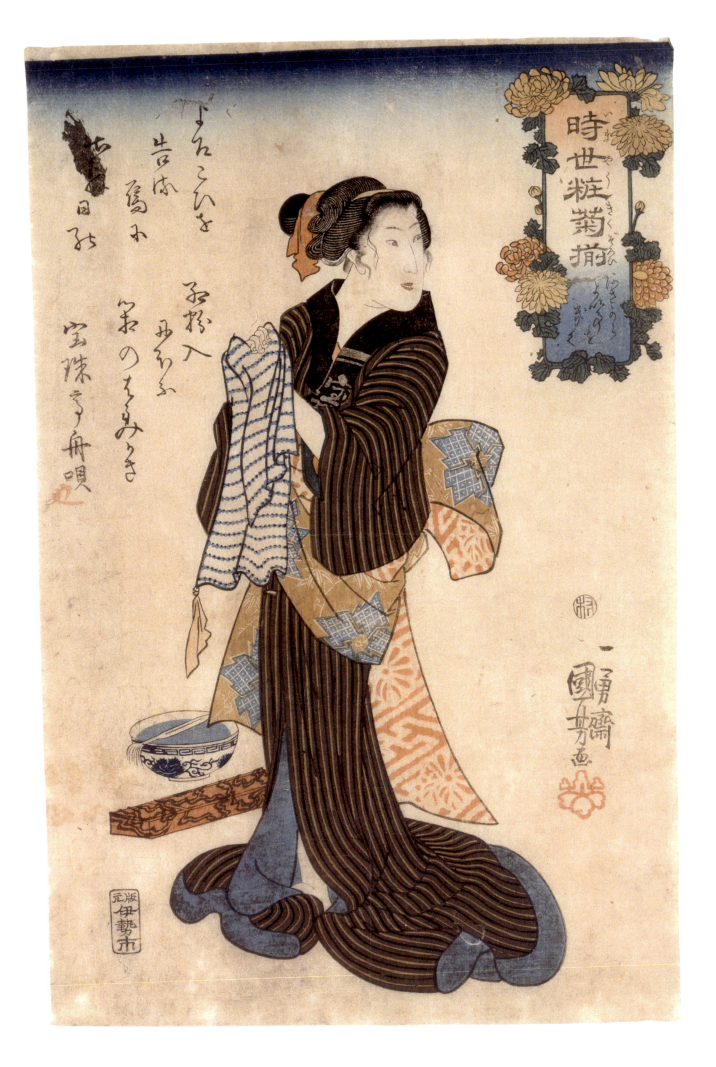

One Hundred Poems Each by a Different Poet, Likened to the Ogura Version: No. 48, Priest Egyō

Ogura gi hyakunin isshu, 48 ban, Egyō hōshi

小倉擬百人一首　四十八番　恵慶法師

Kōchōrō Toyokuni
香蝶楼豊国

ca. Kōka 4 (1847)
弘化 4 年頃

Washing the face using a tub

The *One Hundred Poems Each by a Different Poet, Likened to the Ogura Version* is a set of 100 works collaboratively designed by Toyokuni, Kuniyoshi, and Hiroshige. The upper part of each is a captioned illustration of a poem from the Ogura version of the *One hundred Poems Each by a Different Poet*. This series was the subject of much discussion since it was designed by the three great masters of the time. Currently the POLA Research Institute of Beauty & Culture owns two such works – this one of Priest Egyō and No. 60, Koshikibu no Naishi. There is little connection between the poem and the picture in these works, and each is just a depiction of a beauty at her toilette.

Egyō was not only a Buddhist monk of the mid Heian period (794-1185), but also a poet so highly regarded as to be selected for *Chūko kasen sanjūroku nin den* (Biographies of thirty-six immortals of poetry) and *Shūi wakashū* (Collection of gleanings of poems). The poem in the inset reads "Yae mugura shigereru yado no sabishiki ni hito koso miene aki wa kinikeri (How lonely this house / overgrown with goosegrass weeds. / No one visits me– / only the weary autumn comes.)* ". The 'loneliness' is repeated in the explanatory text.

The woman is wringing out a *tenugui* in a large tub filled with water. It would seem that what is hanging over the rim of the tub is probably a rice-bran bag, suggesting that she has just washed her face. Behind her is a black dressing table, which she is probably about to assemble so that she can use the table. She is wearing a striped kimono and her hair is in the *tsubushi*-Shimada style.

It would be interesting to examine the whole set of 100 prints of this *One Hundred Poems Each by a Different Poet, Likened to the Ogura Version* series in order to see what kind of beauties are depicted.

* McMillan, Peter, *One Hundred Poets, One Poem Each: A Translation of the Ogura Hyakunin Isshu*, Columbia University Press, 2008.

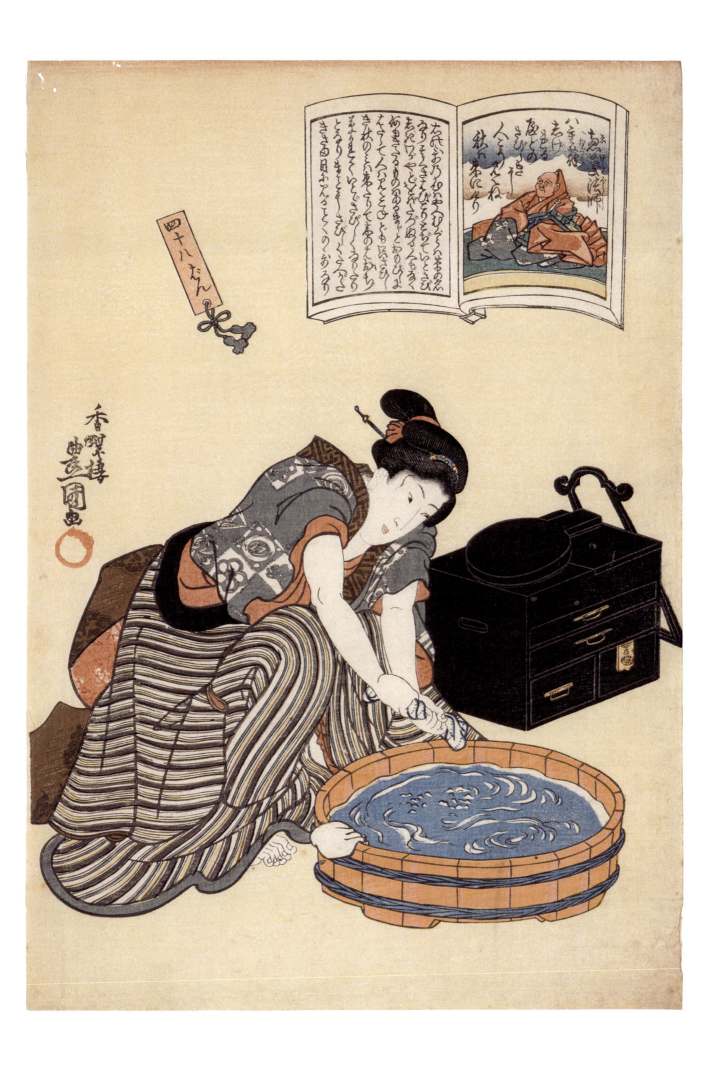

Fujibitai (Mt. Fuji-shaped forehead)
Fujibitai

婦嬲美多意

Keisai Eisen
渓斎英泉

ca. Bunsei era (1818-30)
文政頃

A synonym for a beautiful woman

The woman reveals a *tenugui* with a tie-dyed pattern of Japanese abacus beads draped over her shoulder, with a red bran-bag attached. She may be a geisha or courtesan, and is staring at a signboard advertising Bien Senjokō. Carrying a *yukata* under her arm, she is probably about to visit a bathhouse. A hairpin of a section of bamboo with leaves is inserted into her *tsubushi*-Shimada hairstyle.

Bien Senjokō, as detailed on the signboard, is a white face powder sold by Sakamoto at Inari Shinmichi, 3-chōme, Minami Denmachō, Kyōbashi, Edo. As has already been discussed in connection with Keisai Eisen's print *Bien Senjokō*, this white powder was named after Senjo, the haiku pen-name of Segawa Kikunojō who was a renowned actor of female Kabuki roles around the Kansei era (1789-1801). According to a collection of packages of white face powder owned by the POLA Research Institute of Beauty & Culture, Bien Senjokō's testimonial reads "Miracle remedy for the face, white face powder Bien Senjokō". This product achieved great popularity among women, possibly because it was not just a face powder but also claimed to be effective in whitening the skin and making it smooth while, at the same time, also being effective in treating scabies, freckles, pimples, and heat rash.

The inscription in the gourd reads *fujibitai*, a phonetic equivalent of 'Mt. Fuji-shaped forehead'. This expression is synonymous with a beautiful woman in terms of white face make-up, praising the beauty of the shape of the hairline.

The woman's kimono has a plaid pattern combined with a design similar to *arare-komon* (small and large dots), while her inner kimono depicts chrysanthemums and butterflies. Her *obi* is a *chūya-obi** of stripes with a fret pattern. The *yukata* under her arm has an auspicious bat motif in white on a colored ground. Her clogs are Dōjima-*geta* (a type of low, wooden clogs with a *tatami*-mat lining, originally worn by rice brokers in Dōjima, Osaka). At around this time, the Bunsei era (1818-30), these might have been the latest fashion. Most-likely depicted in the fan-shaped inset, are the Sensō-ji temple and five-storied pagoda in Asakusa.

* *Chūya-obi* is a sash with a pattern or color on one side and another pattern or color on the other.

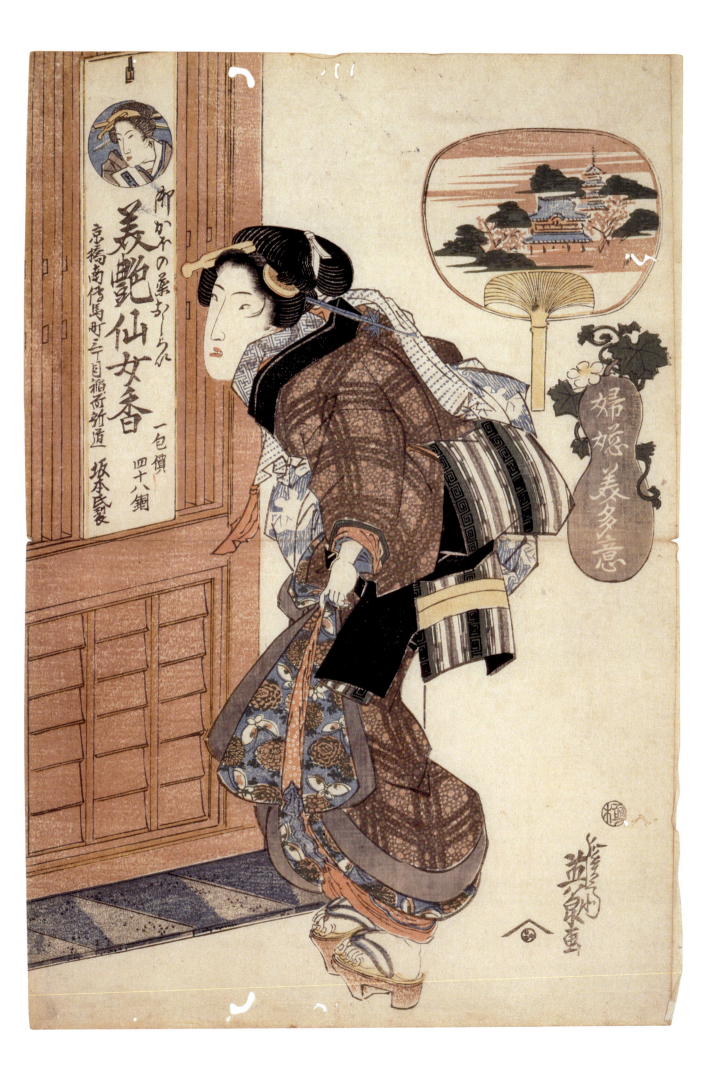

A Scene of Courtesans at their Toilette
Kimitachi atsumari yosooi no zu

君たち集り粧ひの図

Utagawa Toyokuni
歌川豊国

Ansei 4 (1857)
安政 4 年

From tooth-blackening to nail-cutting

This is probably a morning scene at a brothel in the Yoshiwara pleasure quarters. A courtesan is clipping a toenail with the scissors in her right hand. In her mouth is a *tenugui* with a red rice-bran bag attached. The girl next to her, wearing a kimono with a *noshi** design and handing a long *kiseru* (smoking pipe) to a female hairdresser, is a *kamuro*, an apprentice-courtesan working in a brothel.

The female hairdresser, an *onna-kamiyui*, has a *maru-mage* hairstyle and blackened teeth, while having shaved eyebrows. *Motoyui* (paper strings for tying the hair) are tucked into her apron at the waist. Since she is probably very experienced, the hairdresser is about to smoke while doing the courtesan's hair. The courtesan whose hair she is arranging, is in turn doing the hair of another *kamuro* (apprentice).

The courtesan next to them, resting her elbow on a dressing table, has a Shimada-*mage* hairstyle with a short forelock. She has blackened teeth and may be a high-ranking courtesan. She has a toothpick in her right hand and something resembling a teacup in her left.

The woman with a comb inserted in the side of her hair and cleaning her tongue with a tufted toothpick, is also a courtesan. In front of her are tooth-blackening accessories, such as *mimidarai* (washbasin with ear-like handles) and an *ugai-chawan*, suggesting that she may be about to blacken her teeth.

The practice of tooth-blackening among Yoshiwara courtesans was limited to those of high rank. It was practiced as a token of chastity for their customers, although just for one night. They used the same types of tooth-blackening accessories as those of ordinary women. However, they are said to have bought tooth-blackening liquid from peddlers rather than make it themselves owing to its foul smell. The book *Ehon imayō sugata* (Picutre-book of modern figures of fashion), Kyōwa 2 (1802), has a depiction of a female peddler in front of a brothel, holding a pot inscribed *ohaguro* (tooth-blackening, おはぐろ).

Among all the women depicted, there is one man who is wearing a *yukata*. He reveals an unusual hairstyle (*ebichasen-mage*), while his *yukata* is decorated with a Genji-wheel pattern with hollyhocks. If we look closely at the *tenugui* hanging over the mirror-stand to the left of the female hairdresser, it has a design of symbols for incense based on the *Tale of Genji*. These may imply that this man is Ashikaga Mitsuuji, the main character of *Nise Murasaki inaka Genji*** (Parody of the *Tale of Genji*) by Ryūtei Tanehiko (an unfinished bound volume, illustrated by Utagawa Kunisada, published in Bunsei 12 – Tenpō 3 (1829-32)).

Although this scene of courtesans at their toilette appears busy, it nevertheless seems somewhat relaxed. This may reflect a short period of time for themselves.

* *Noshi* was originally a bundle of dried slices of abalone meat used as a gift, which then became an auspicious motif.

** This novel is a parody of the *Tale of Genji*, by Murasaki Shikibu, written around the early 11th century.

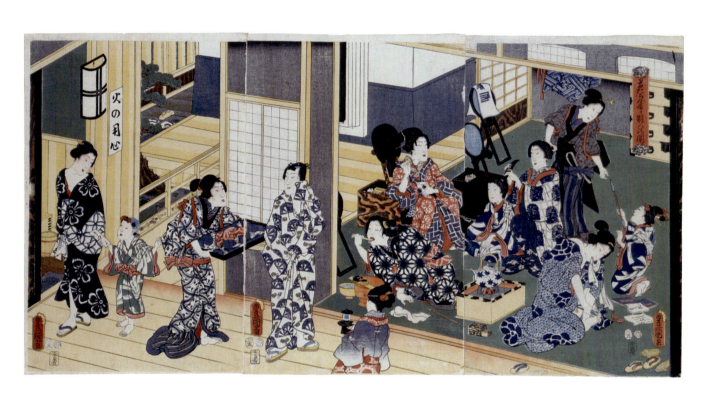

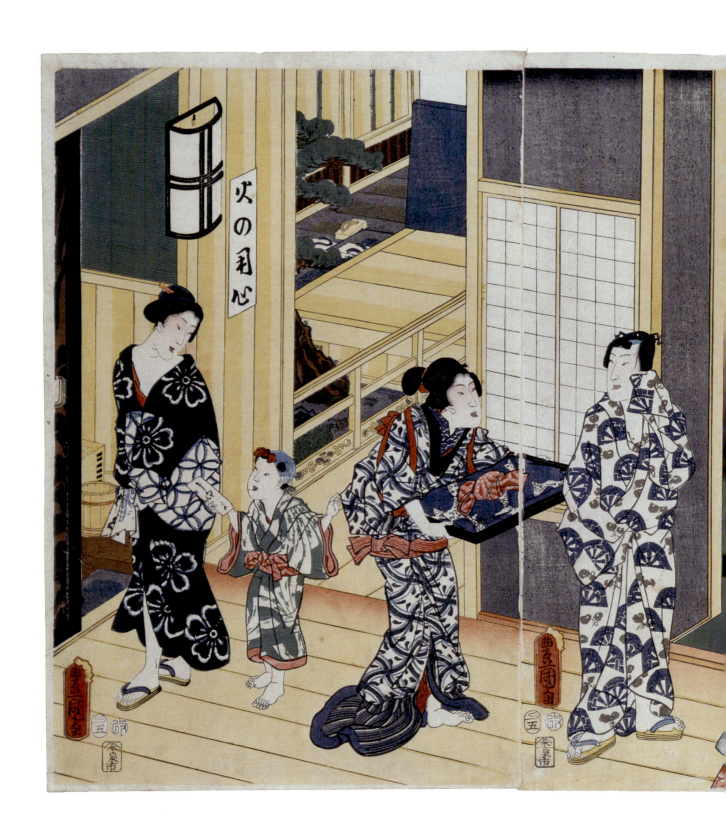

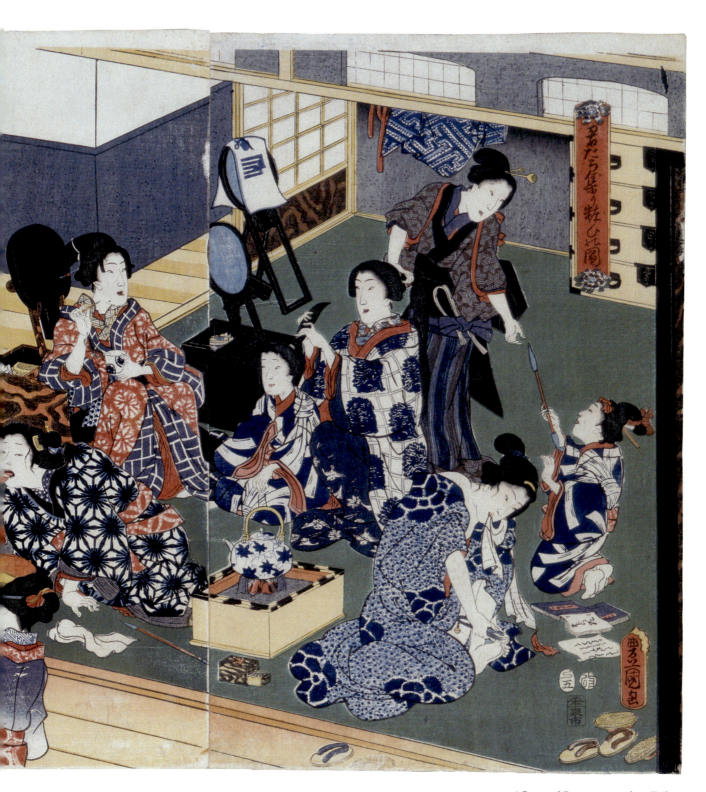

A Scene of Courtesans at their Toilette

Seven Episodes of Ono no Komachi and Customs of the East: Sōshi Arai

Nana Komachi Azuma fūzoku, sōshi arai

七小町吾妻風俗　さうしあらい

Baichōrō Kunisada
梅蝶楼国貞

Ansei 4 (1857)
安政 4 年

The act of washing

Baichōrō Kunisada was born in Bunsei 6 (1823). When he worked under the name Kunimasa III, he also used the pseudonym Baidō, while he gave himself the pseudonym Baichōrō upon succeeding Kunisada II in Kōka 3 (1846). The theme of this print was taken from 'Sōshi arai Komachi (Komachi Washing the Book)', one of the seven episodes of Ono no Komachi, while playing on the word 'washing', that is, washing the face and cleaning the teeth in the morning at a brothel.

The courtesan on the right with blackened teeth and a *tsubushi*-Shimada hairstyle, is wearing a kimono with patterns of *matsukawabishi* (a series of lozenges) in a *dangawari* (lit. stepped change) manner. She is also wearing a *chūya-obi* with a floral rhombus pattern on one side and hemp-leaf pattern on the other. In her hand she holds a *tenugui* inscribed Kuniyoshi (国吉) which she is pressing to her face. The girl next to her is carrying a *yukata* and a *tenugui*. It is possible that they have just emerged from the bathroom behind the split-curtain with a Benkei-check pattern.

The courtesan in the middle is holding a rice-bran bag in her mouth, while washing her hands in the metal washbasin. It must be a *yukata* that she is wearing, inscribed with the name Utagawa Kunisada (歌川国貞).

The courtesan on the left with a *tenjin-mage* hairstyle may be wearing an inner kimono with a purple check pattern. She is about to brush her teeth with a tufted toothpick using tooth powder that contains rouge. A closer look reveals that the tip of her tufted toothpick is red. This type of toothpick is made from a willow branch cut into the shape of a chopstick, with the end beaten into a tuft. The tooth powder containing rouge was most likely made from Bōshū-*zuna**, scented with such fragrances as borneol, clove and sandalwood, to which rouge was added. This was also widely used by the general public.

This seems to be a busy morning scene, showing the women trying to be neat and tidy in their personal hygiene.

* Bōshū-*zuna* is polishing sand from Bōshū (another name for Awa province, southern part of present-day Chiba prefecture).

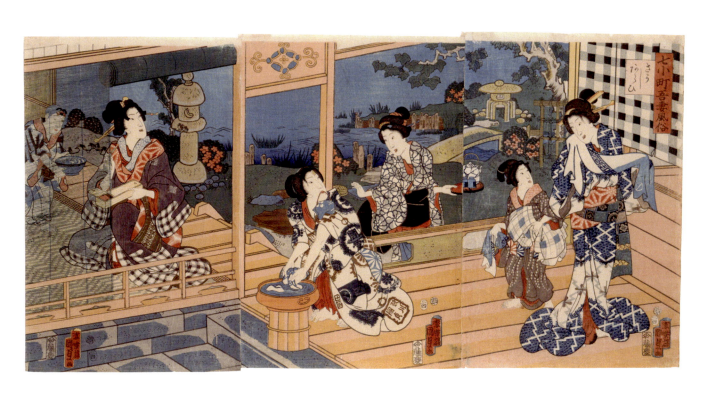

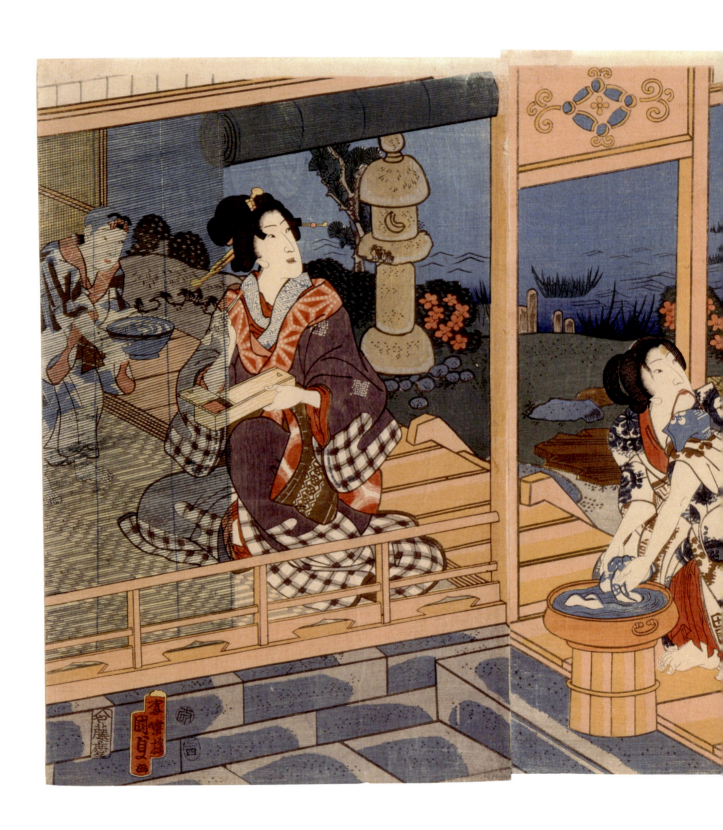

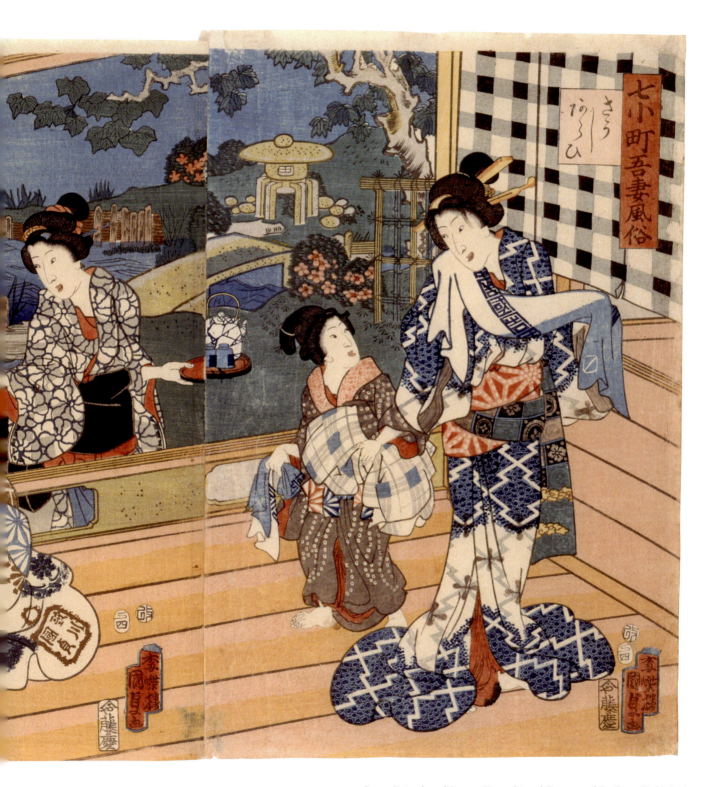

Seven Episodes of Ono no Komachi and Customs of the East: Sōshi Arai

Comparison of Fashionable Beauties
Ryūkō bijin awase

流行美人合

Kōchōrō Kunisada
香蝶楼国貞

ca. Bunsei era (1818-30)
文政頃

A dressing room scene

This *Comparison of Fashionable Beauties* is thought to depict an *okabasho* in Honjo Hitotsume, Edo, and seems to be a series of several prints. In this context, it is worth noting that o*kabasho* are unlicensed pleasure quarters other than the licensed Yoshiwara. As we can make out a staircase, this print seems to portray the upper floor of a brothel. All of the women are in the process of grooming themselves.

The courtesan on the right is wearing a kimono decorated with what appears to be a design of *mochibana* (New Year's hanging decorations) on a pink ground with purple gradation, while tying an *obi* of *yūsoku-mon* (traditional design motifs used by court nobles). Her hair is in the *tsubushi*-Shimada style, into which a long, flat board-like *kōgai* (hair stick) is inserted. She has probably already finished her make-up.

The courtesan in the middle may just have started applying her make-up; she is biting the tip of a tufted toothpick, while holding an *ugai-chawan* in her left hand. She may be about to wash her face, as we can see a tub of water at her feet.

The courtesan on the left, who is leaning on a dressing table with a toothpick in her mouth, seems to be holding a pair of tweezers in her right hand. She is wearing a Benkei-check *uchikake* (long overgarment) over a kimono with a bat pattern. Her hair is in the *tsubushi*-Shimada style with a red *tegara* (decorative cloth). The white face powder, Bien Senjokō, is next to a dressing table whose pattern is almost like wood-grain.

This probably depicts a dressing room with four dressing tables in a row in black or with apparent wood-grain designs, and such a room is just what one might expect to find in a brothel. The paper lantern in the top middle bears a design of *tsuta* (ivy), possibly suggesting that the brothel is named Tsuta-ya. The *tenugui* on the wall behind the lantern is cleverly inscribed in a throw-away manner Kōchō (香蝶) from Kōchōrō Kunisada (香蝶楼国貞) and *toshidama*, the emblem of the Utagawa school. It is interesting to see the three courtesans preening themselves in a variety of ways while, at the same time, chatting in front of the dressing table that belonged to each.

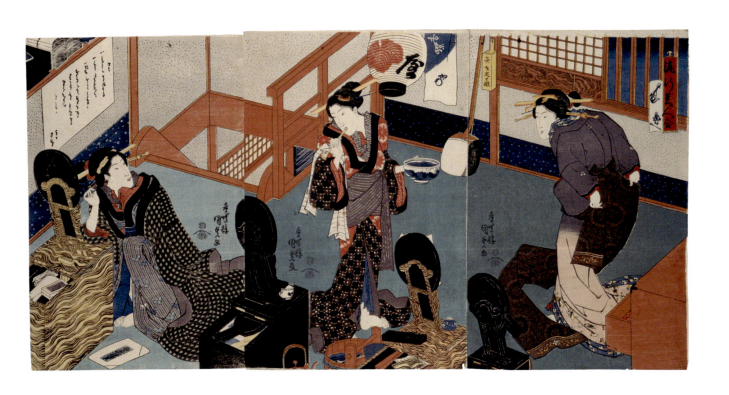

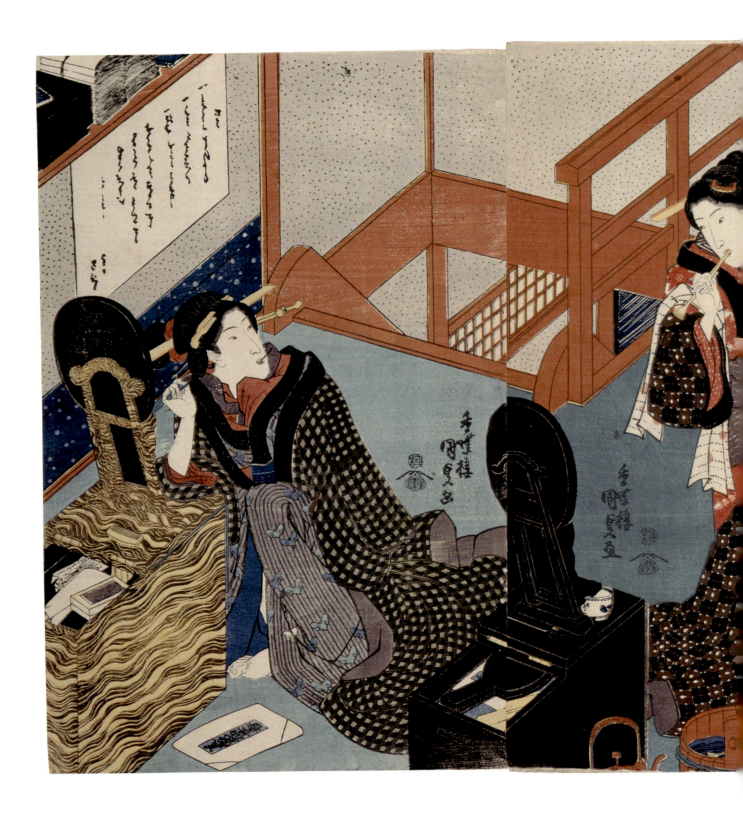

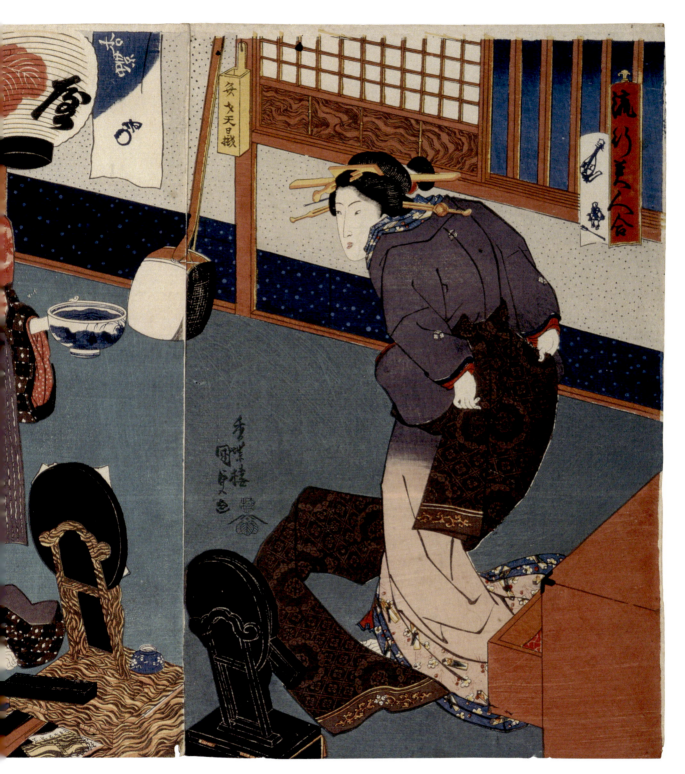

Comparison of Fashionable Beauties

One Hundred Famous Places of Edo: Komagata-dō Hall and Azumabashi Bridge

Edo meisho hyakkei, Komagata-dō Azumabashi

江戸名所百景　駒形堂吾妻橋

Utagawa Hiroshige
歌川広重

Ansei 4 (1857)
安政4年

Hyakusuke's red flag

This is a print of the roof of Komagata-dō hall in Asakusa, while the red item is the banner of Nakajimaya Hyakusuke, a cosmetic shop located diagonally across from the hall. The Azumabashi bridge can be seen behind the roof of the hall, while the timber-like structure to the right of the banner does not appear in topography of the same area in the book *Edo meisho zue* (Illustations of famous places in Edo), published in the Tenpō era (1830-1844). It is possible that Hiroshige added the timber for the balance of the composition. The bird flying in the sky is a little cuckoo, probably added to allude to a letter sent by the Yoshiwara courtesan Takao II to her lover Date Tsunamune, the lord of the Sendai domain, with whom she had just parted reluctantly upon his leaving. The letter reads: "Kimi wa ima / Komagata atari / hototogisu (By now, have you / reached Komagata / Oh, little cuckoo!)*." It is worth mentioning that Hiroshige depicted a small cuckoo in the same angle in the book *Kyōka Edo meisho zue* (Illustations and comic poems of famous places in Edo), published in Ansei 3 (1856).

The Komagata-dō hall enshrines Batō Kannon (horse-headed bodhisattva in wrathful form); since the horse is sometimes called *koma* in Japanese, the name of the hall Komagata contains the word *koma*. During the Edo period, Batō Kannon was widely revered as a guardian deity for horses and a safe journey. Although the Komagata-dō appears to be large, it is in fact only a small building. Since it was built slightly raised above the riverbank, the composition was conceived in such a way that the viewer looks down from above.

Incidentally, since the red banner mentioned above indicates the location of Nakajimaya Hyakusuke's shop, this print is said to have been intended as an advertisement for Hyakusuke rather than one of the 'One Hundred Famous Places'. However, the little cuckoo and Komagata-dō on their own would have resulted in a rather dull print, without sufficient movement and interest. It is the fluttering red banner of Hyakusuke, however, that brings this scene to life.

* Machotka, Ewa, *Visual Genesis of Japanese National Identity: Hokusai's Hyakunin Isshu*, P.I.E Peter Lang, 2009.

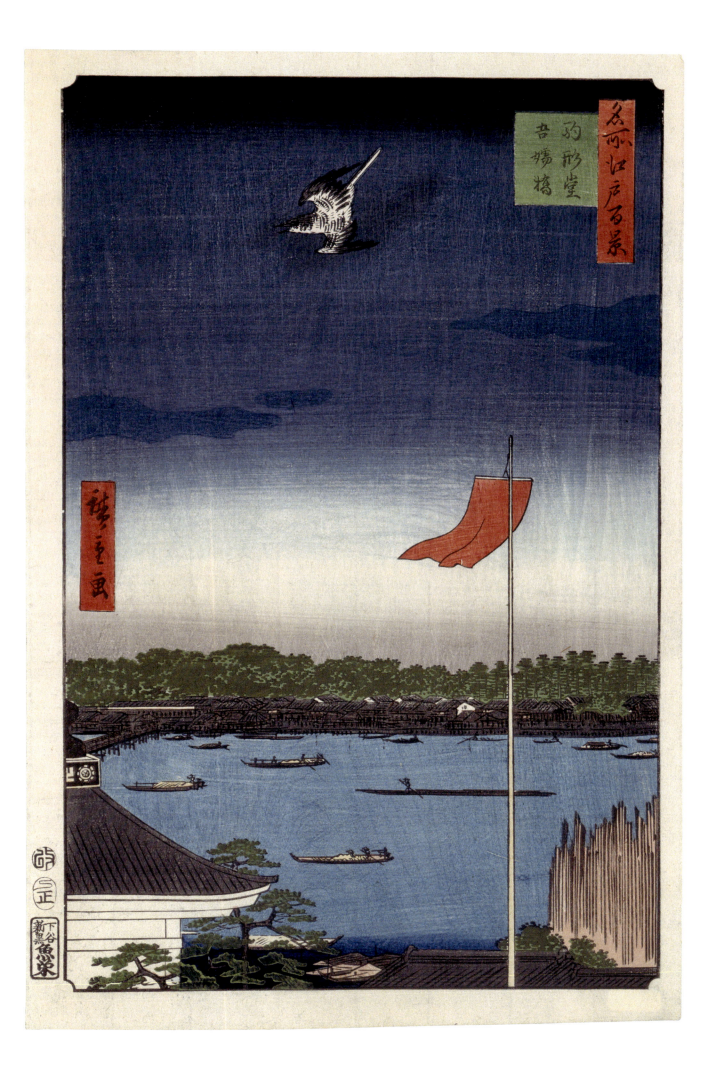

Fashionable Life-size Dolls: Kume no Sennin
Tōsei mitate ningyō no uchi, Kume no Sennin

当盛見立人形之内　粂の仙人

Ichiyūsai Kuniyoshi
一勇斎国芳

Ansei 3 (1856)
安政3年

*Sennin** and white face powder

Kume no Sennin is a mythical figure. In order to lead an ascetic life, he went into seclusion at the Ryūmon-ji temple in the Yoshino district, Yamato province, and gained the power of levitation. However, when a young woman was washing clothes by the Yoshinogawa river, he was so captivated by her bare white legs, that this carnal desire caused him to lose the power of flight, and he fell to the ground. As a result, he took her as his wife and returned to a secular life. Later, on the occasion of the capital being moved to the Takaichi district, he undertook austere training again and prayed for seven days and nights, recovering his magical powers, and was able to make timber fly from the mountains to the new capital to use for construction. Due to this feat he was given 30 *chō* of tax-free agricultural land on which he built the Kume-dera temple.

As an allusion to this legend of Kume no Sennin, there is a story from the Edo period in which a merchant's wife used white face powder to paint her legs white, including her inner thighs.

The story appears in *Haruasobi kigen bukuro* (Collection of humorous stories) written by Koikawa Harumachi in An'ei 4 (1775), as an episode of the first bath of the year, which roughly translates as "When going to a bathhouse to take the first bath of the year, the merchant's wife in the backstreet area wore a kimono of striped Hachijō pongee with gold embroidered crests, with her wide Ryōgoku *obi* half tied. Her legs, including her inner thighs, were painted with white face powder, and she began to walk in the form of the outward character *hachi* (lit. eight, 八)**. Passers-by took one look at her ridiculously-white legs, …an apprentice accompanying the merchant's wife was astounded, shuffled around, and stumbled over a stone, tripping over the hem of her kimono. She turned around and asked, "Hey Chōmatsu, what was that?" Chōmatsu replied, "It was me, who tripped and fell." Then she said, "Hmm, I thought it was the *sennin*…" This repartee is almost like a comedy in *rakugo****.

This story not only deals with legs, but also extends to the whiteness of inner thighs. Although they were naturally light in color, the wife was so particular about her legs and so confident that she had painted them white, that she even referred to Kume no Sennin. To paint one's inner thighs white, however, did not seem to catch on.

* *Sennin* are immortals who have acquired magical powers through meditation, ascetic practice, and following Daoist teachings.

** In other words, her legs and feet turned open in the 'ten to two' position.

*** *Rakugo* is the traditional art of comic story-telling.

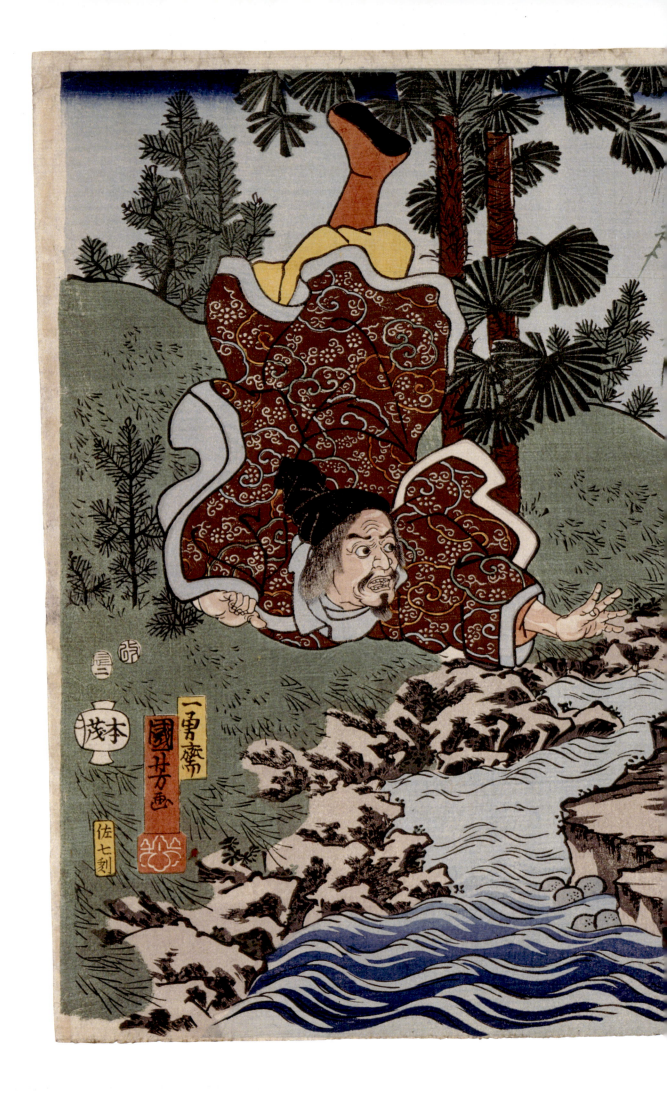

Fashionable Life-size Dolls: Kume no Sennin

Women's Customs
Fujin tashinami kusa

婦人たしなみ草

Kōchōrō Kunisada
香蝶楼国貞

Kōka 4 (1847)
弘化 4 年

Combing one's hair

The series *Women's Customs* depict such scenes as sewing, while the best known among the series is said to be this one representing hair-combing.

In the Edo period, long hair was combed with the hair falling forward. This woman's hair seems newly washed as, hanging from her shoulder and over her back, is an apron with an arrow-like pattern, while its sashes are tied at her chest. Her kimono has a pattern of ivy-like leaves with small flowers, and the inner kimono depicts a bird pattern on a blue ground. Held in her right hand is a *tōgushi* comb with teeth on either side, while placed on the *tatō* paper on the floor are *nigiri-basami* (scissors), *kushiharai* (brush to clean combs), *kesujitate* (narrow comb with a long pointed handle for parting the hair), *motoyui* (strings), *tokikushi* (wide-toothed comb), and so forth.

The text beside the title box is a prose by Kinsui Rōjin, in which he states how important hair and make-up are to women.

It is worth noting that this woman's hair is indeed long. In fact, hair of this length was necessary for traditional Japanese women's hairstyles, so-called Nihon-*gami*.

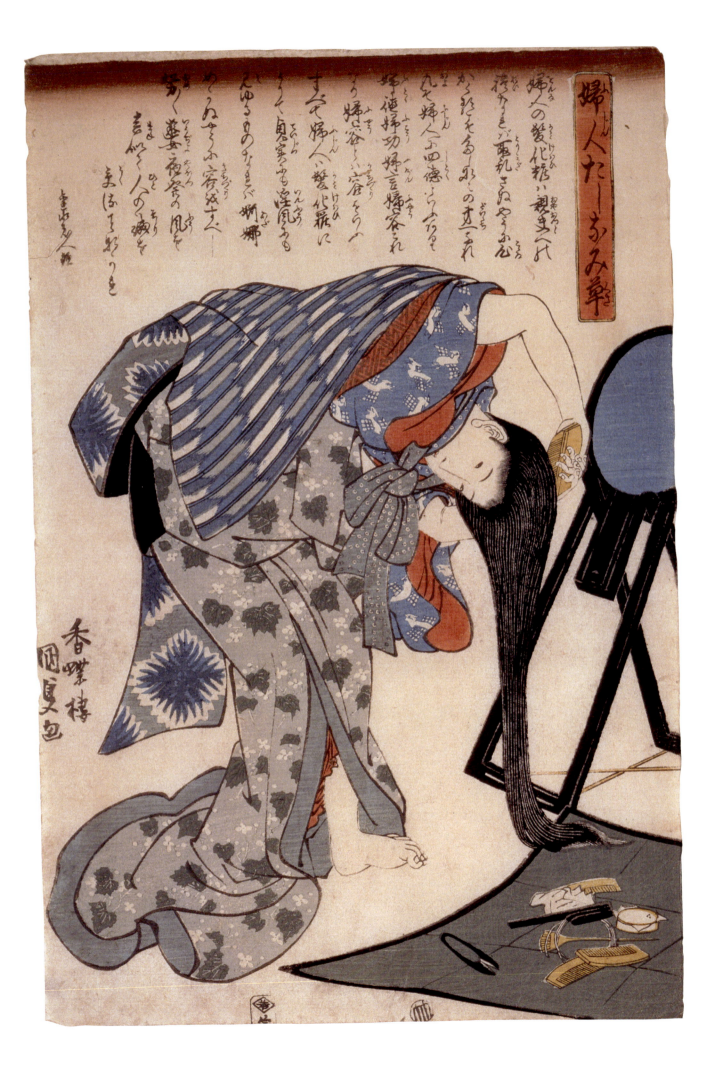

Pictorial Commentary of One Hundred Poems Each by a Different Poet: No. 78, Taikenmon-in Horikawa

Hyakunin isshu eshō, 78, Taikenmon-in Horikawa

百人一首繪抄　七十八　待賢門院堀川

Kunisada renamed Utagawa Toyokuni II
国貞改二代歌川豊国

Kōka 4 (1847)
弘化 4 年

Arranging one's hair by oneself

This woman, putting her hair into a ponytail in front of a black dressing table, still appears to be young. Held in her mouth is a *motoyui* (a strip to tie hair on top of the head, while previously braided cord or hemp yarn had been employed, and glued paper strings, called *mizuhiki motoyui*, were used in early-modern times when ingenuity was applied to topknots).

Her kimono has circular motifs such as cherry blossoms, chrysanthemums and umbrellas. The inner kimono reveals a plum-blossom pattern on a red ground, and the design on her *obi* may be that of mandarin ducks. In the dressing table, a package of white face powder inscribed Usuzakura (lit. pale cherry blossom, うす桜) is visible.

In the top left are a *yomifuda* (reading card) and a *torifuda* (grabbing card) from the card game of *One Hundred Poems Each by a Different Poet**, these being inscribed with a poem by Taikenmon-in Horikawa, which reads: "Nagakaramu kokoro mo shirazu kurokami no midarete kesa wa mono o koso omoe (I do not know if you / will always be true. / This morning after you left, / I recalled your vows to me / looking at my long black hair / so disheveled– / like the tangles in my heart.)**." This poem seems to mean, "I spent the night with you last night and, even though you said you would not have a change of heart forever, your true feelings are so hard to guess that my thoughts are in a tangle just as my hair is this morning, and I am lost in thought."

Taikenmon-in Horikawa, a poet from the late Heian period (794-1185), served the Empress Taikenmon-in (named Shōshi, the wife of Emperor Toba), who was the biological mother of Sutoku-in, and was called Horikawa.

As the poem suggests, it makes us wonder whether the woman tying her hair in the print is feeling upset inside. Although this is not conveyed by her facial expression, it is, after all, difficult to read a woman's mind.

* The card game of *One Hundred Poems Each by a Different Poet* consists of 100 cards called *yomifuda* (reading card) and another 100 cards called *torifuda* (grabbing card). Each *yomifuda* is fully inscribed with one of the poems from *One Hundred Poems Each by a Different Poet* with illustration, and its corresponding *torifuda* has only an inscription of the latter part of the poem. All the *torifuda* are scattered on the floor, and while one person reads the *yomifuda*, players look for and pick up the matching *torifuda*. The winner is the player who gets the most cards.

** McMillan, Peter, *One Hundred Poets, One Poem Each: A Translation of the Ogura Hyakunin Isshu*, Columbia University Press, 2008.

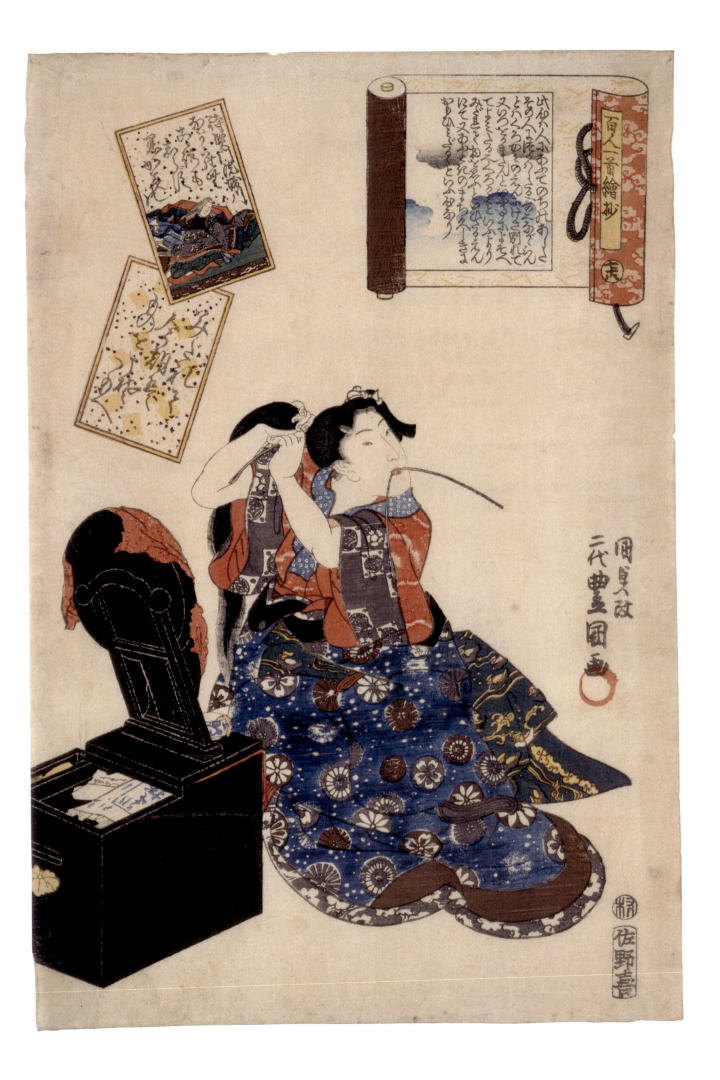

Hauta Songs in a Book of Secrets
Hauta toranomaki

葉うた虎之巻

Toyohara Kunichika
豊原国周

Bunkyū 2 (1862)
文久 2 年

Onna-kamiyui (female hairdresser) at a brothel

This is one of 13 prints that form a set. A *heyamochi yujo** is having her hair styled by a female hairdresser called an *onna-kamiyui*, while receiving a pipe for smoking from a *kamuro* apprentice. She is also holding a letter, which she seems to have recently finished writing, as a writing box can be seen beside her.

The courtesan is wearing a red tie-dyed dressing-gown with a *karahana* (Chinese flower) design that appears to frame the gown, and the *obi* is tied at the front. She is sitting with one of her knees drawn up close to her chest. The hair of the *kamuro* seems to be in a style called *bon no kubo***, while her kimono is decorated with a *tabane-noshi* (bound-gift strips) pattern.

The hairdresser has a hairstyle known as *bai-mage* (topknot shaped like a spiral shell), into which is inserted a *kesujitate* (narrow comb with a long pointed handle for parting the hair), one of her professional tools. She is likely doing the courtesan's hair up into a Shimada-*mage* and is about to form the topknot. The sleeves of her Benkei-check kimono are tucked up with a sash, and one end of her *obi* is flowing at the back.

Behind the *kamuro* is likely a box with the implements of the *onna-kamiyui*, as we can make out various combs. *Onna-kamiyui* were indispensable to courtesans. It is said that, around the An'ei era (1772-81), courtesans had a monthly contract with them and seem to have paid two *bu* (that is, half one *ryō*), which would cover around 10 sessions, assuming that one session cost 200 *mon*. Grooming was indeed costly.

The upper part is seemingly inscribed with a *hauta* (short song sung to the shamisen) of love and its parody. The letter written by the courtesan may be similar in content, one of the wiles of a courtesan.

* *Heyamochi yūjo* is a high-rank courtesan who has her own room at a brothel.

** *Bon no kubo* was a child's hairstyle during the Edo period in which all the hair is shaved off except fine soft hair along the hairline, particularly at the nape of the neck.

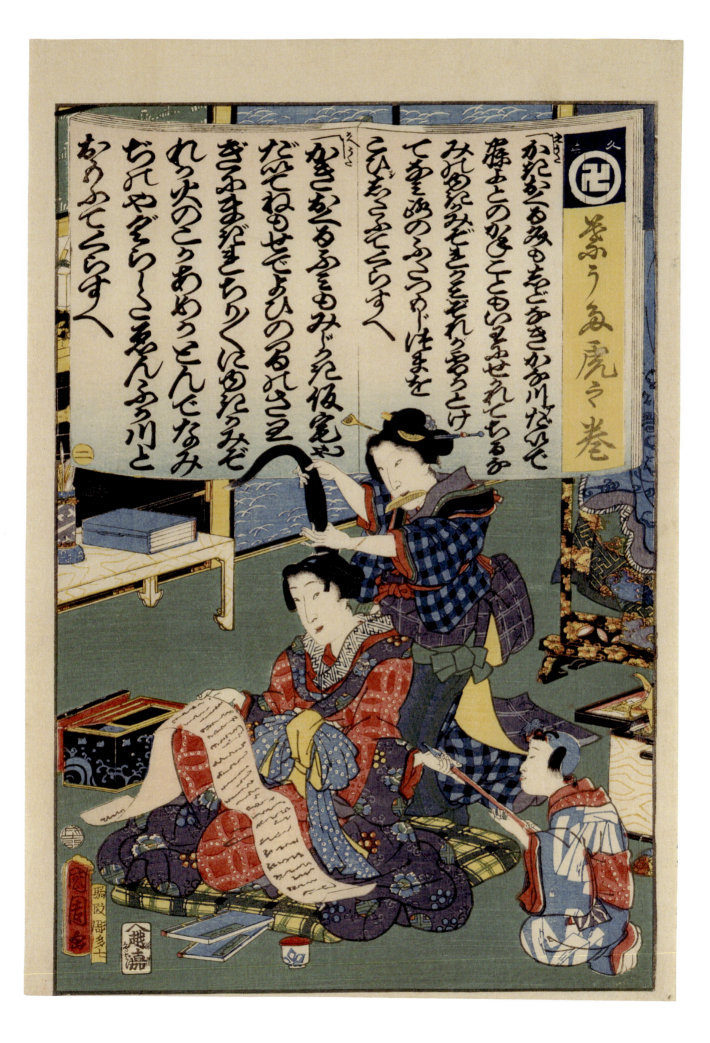

Pleasure of a Rainy Spring Evening

Harusame yutaka no yūbae

春雨豊夕榮

Utagawa Toyokuni
歌川豊国

Ansei 2 (1855)
安政 2 年

The work of *onna-kamiyui*

This is likely an afternoon scene at a busy brothel. With her sleeves tied out of the way with a sash, the *onna-kamiyui* with no eyebrows is tying the topknot of a woman with a *motoyui* string. She is probably going to arrange a Shimada-*mage* hairstyle and has some *motoyui* tucked into her apron. The woman having her hair styled may be a high-ranking courtesan of the brothel. She seems to be listening to the courtesan next to her, who has a *tenjin-mage* hairstyle and is talking about the letter.

The courtesan who is standing on the right seems ready for work, holding the hems of her garments in her left hand. Her hair is in the *tsubushi*-Shimada style, and she is wearing a kimono with a cherry blossom design and a black *obi* with a butterfly motif.

At her feet, a courtesan is playing a shamisen. Her kimono has a pattern of *nikuzushi* (alternating double blocks), and the *obi* tie-dyed *sayagata* (a variation of interlocking swastika). Her hairstyle is a *jiretta-musubi*, in which the hair is tied casually at the lower back of the head.

The courtesans on the left in the *kotatsu** are probably having their break.

Hanging over the lattice at the back of the room is a *tenugui* inscribed with the name Utagawa (歌川) and dyed with *toshidama*, the crest of the Utagawa school. On the shelf are a *mimidarai* and *ugai-chawan* for blackening the teeth, toothpick box, water pitcher, earthenware teapot and teacup, as well as a two-tiered round receptacle containing food. If we look closely at the black dressing table in the middle, the drawers are on the left side, whereas they are usually on the right; these drawers would have to be opened and closed with the left hand. Toyokuni rendered it this way without considering practicalities.

The chattering of voices and the sound of the shamisen – this print conveys the animated atmosphere.

* *Kotatsu* is a table covered with a thick quilt, in which a heating device is often placed.

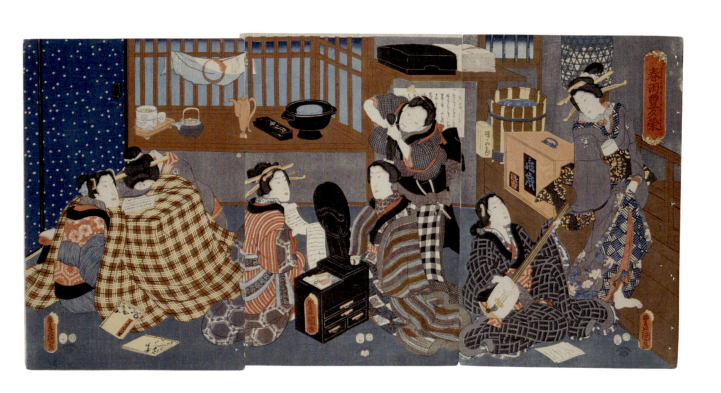

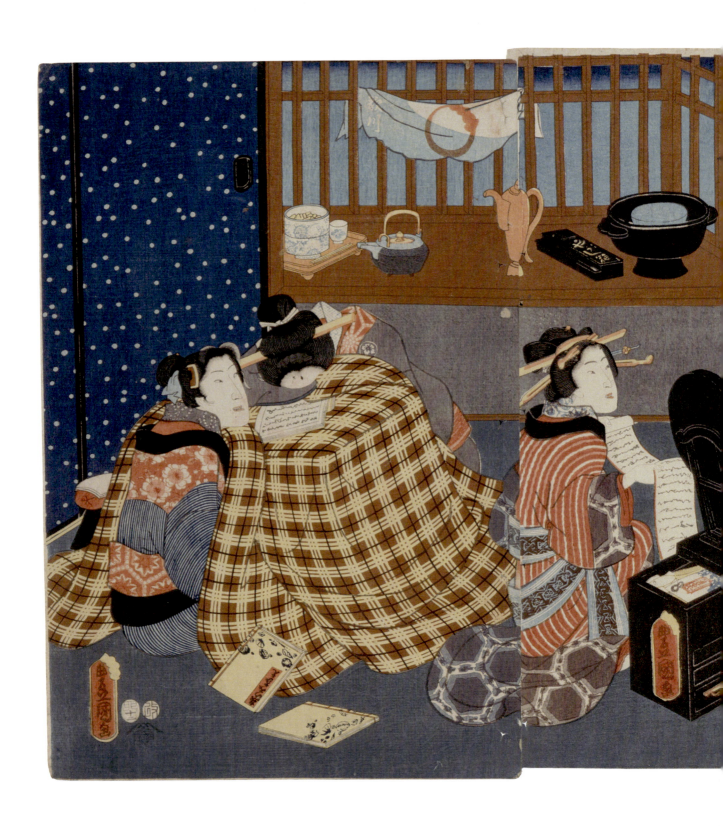

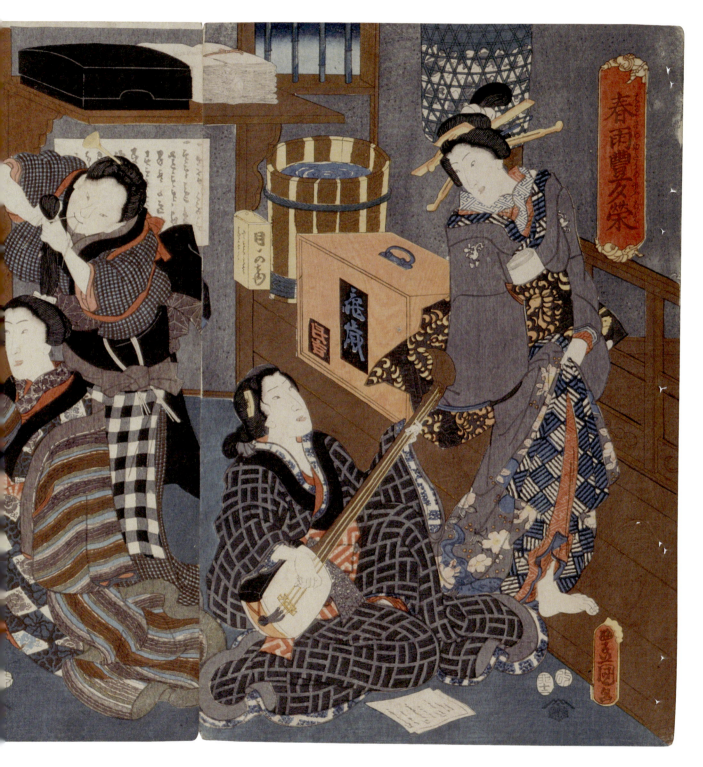

Pleasure of a Rainy Spring Evening

Seven Fashionable Episodes of Ono no Komachi: Seki-dera Komachi, the Courtesan Ōyodo of the Tsuru-ya House
Fūryū nana Komachi, Seki-dera Komachi, Tsuru-ya nai Ōyodo

風流七小町　関寺小町　鶴屋内大淀

Kikukawa Eizan
菊川英山

Bunka 9 (1812)
文化 9 年

A pair of combs for courtesans

The woman checking her mottled tortoiseshell hairpins in the mirror on the chrysanthemum dressing table is Ōyodo of the Tsuru-ya House at 1-chōme, Kyōchō, Shin-Yoshiwara. The annual guidebook, *Yoshiwara saiken,* Bunka 9 (1812) (first published during the Kyōhō era (1716-36), and listing the names of brothels and courtesans in Yoshiwara, Edo), suggests that Ōyodo was a top-rank courtesan, since the book indicates her as *yobidashi* and commanding a high price (*kin* 3 *bu*). The term *yobidashi* refers to a high-rank courtesan who could be contacted by *hikitejaya,* a teahouse that introduced customers to brothels, and the courtesan would escort a customer to her brothel.

In her Shimada-*mage* hairdo is a pair of spotted tortoiseshell combs, which likely form a set with the hairpins. Like her, courtesans would adorn their hair with combs in pairs or sets of three. This was a distinctive fashion among courtesans, with ordinary women wearing only one comb as a hair ornament. Initially a courtesan used one comb for herself and the other for combing the hair of her customer but, over time, both combs came to be solely for decoration. Some courtesans even inserted more than 10 hairpins in their hair, which, people said, looked like the Buddha's halo. The courtesan in this print holds *kaishi* tissues in her mouth, and wears a kimono with a design of chrysanthemums and floral scrolls, while her *obi* of floral rhombi is tied at the front.

Hanging behind her is what appears to be a triple-layered *uchikake* (long overgarment). It is said that Kikukawa Eizan, who designed this print, often depicted women wearing kimono adorned with various chrysanthemum designs, probably because his name includes the word *kiku,* meaning chrysanthemum and his birthday coincided with *Chōyō no sekku* (Chrysanthemum Festival on the 9th day of the 9th month).

The inset is inscribed with a poem attributed to Ono no Komachi: "Omokage no kawarade toshi no tsumorekashi tatoe inochi ni kagiri aritomo"*.

* The poem can be roughly translated as "To age without one's face changing / even though life (and beauty) will come to an end".

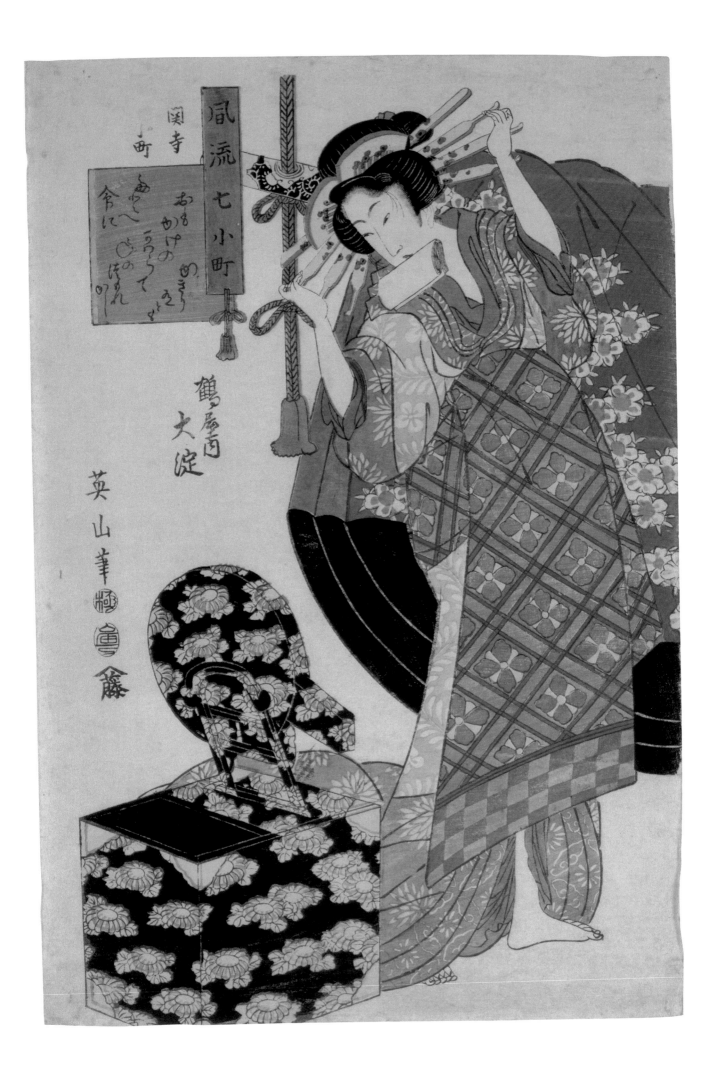

Forty-eight Habits of the Floating World: Those Who Want Everything Are Carefree

Ukiyo shijūhachi kuse, nandemo hoshigaru wa ku nashi no kuse

浮世四十八癖　なんでもほしがる八苦なしの癖

Keisai Eisen
渓斎英泉

ca. mid Bunsei era (1818-30)
文政中頃

Hair ornaments admired by women

The young woman sitting in the *engawa* (veranda) is holding out a *kanzashi* (hairpin) that appears to be made of tortoiseshell. Taking into account the title 'those who want everything', it is likely that this woman probably wants to have this hairpin.

Since the first half of the Edo period, the types of hair ornament most admired by women were undoubtedly combs, hairpins and hair sticks made of tortoiseshell. Since it was difficult to obtain much tortoiseshell in Japan as the natural yield was small, the material was valuable. Hair accessories made of unblemished blond tortoiseshell were even beyond the reach of courtesans.

Since women were very anxious to possess tortoiseshell hair ornaments, craftsmen made imitations called *nitari,* which were made from the hooves of horses and oxen, with which many women were satisfied. However, there was a disadvantage in that they turned whitish in color over time, whereas genuine tortoiseshell acquired a pleasing caramel color.

This girl has a *yuiwata* (a kind of Shimada-*mage*) hairstyle with a red *tegara* and *ryōten-kanzashi*. Her kimono bears a pattern of plum blossoms and maple leaves, and the *obi* that of cranes. Near her left hand a *hagoita* and *hane** can be seen. Is the scene a setting for New Year?

The inset depicts an area around Gotenyama with cherry blossoms in full bloom. Cherry blossoms, however, are too early for New Year. While the seasons do not match, their connection with the girl is also not clear.

* *Hagoita* is a racket for *hanetsuki*, Japanese battledore, and *hane* is the shuttlecock. *Hanetsuki* is played during New Year festivities.

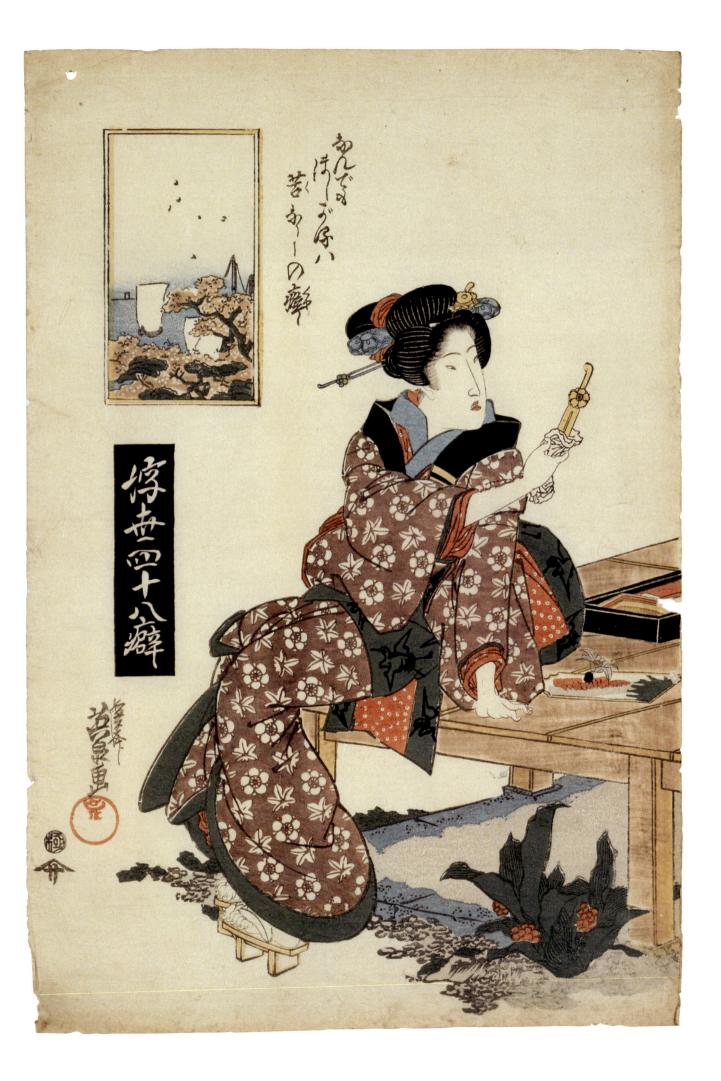

Index of Representative Proverbs: He, Seashore

Tatoegusa oshie hayabiki, he, hotori

譬論草をしへ早引　へ　邊

Chōōrō Kuniyoshi
朝櫻楼国芳

ca. Tenpō (1830-44) – Kōka (1844-48) eras
天保から弘化頃

The hair of *ama* (female diver)*

This woman, casually rolling up her hair, is likely an *ama*. She is wearing a *yukata* with motifs of tie-dyed flowers and paulownia, over which is a grass skirt around the waist. Held in her mouth is probably a hair stick to roll her hair on.

The text beside the title box explains the meaning of the title of this print. According to the text, the Japanese *hiragana* phonetic *he* (へ) was illustrated by an *ama*, alluding to the seashore, while *hotori* (邊) seems to refer to the neighborhood of a grand shrine.

The poem on the left by Ryūtei Tanekazu suggests that the tide is going out and the woman is about to go to the beach to gather shellfish.

This *Index of Representative Proverbs* is probably a series of prints, and that featuring the *hiragana* sound *ha* (は) depicts a scene of tooth-blackening. This series seems to illustrate what women have to know or need to do.

Even today some women still put their hair up in this way. Even though a long time has passed, some things never change.

* *Ama* are professional female divers who collect abalone and other food in the sea.

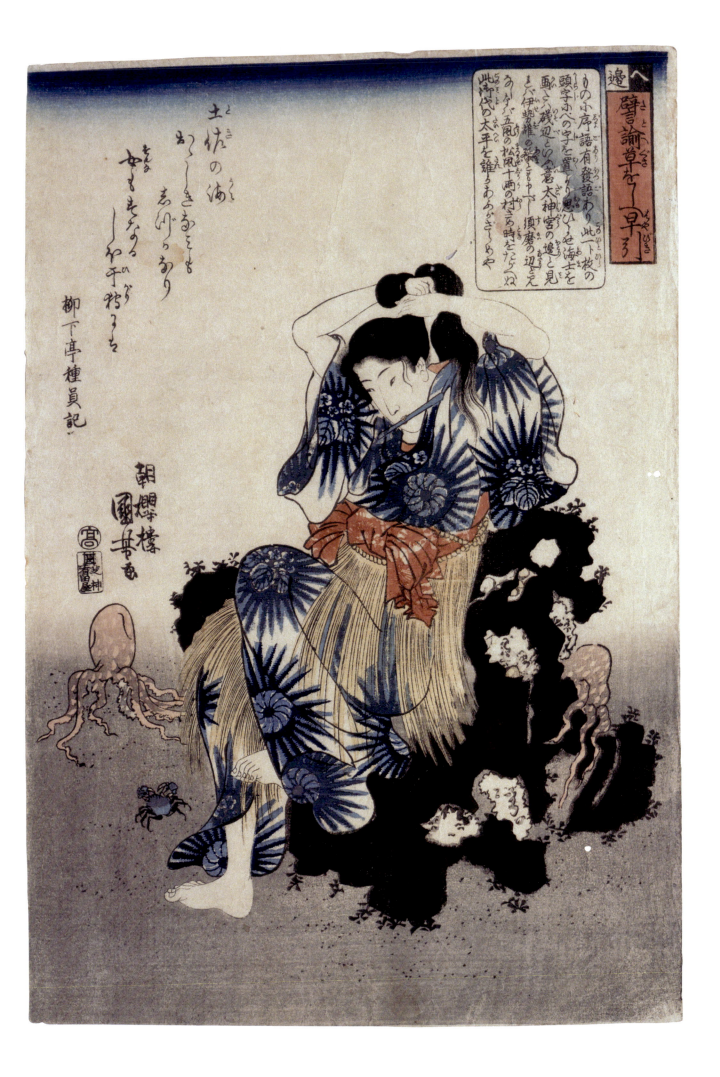

Various Women of the Floating World, Second Series
Ukiyo meijo zue, nihen

浮世名異女図会　二編

Gototei Kunisada
五渡亭国貞

Bunsei 4 (1821)
文政 4 年

Children's hair

The *Various Women of the Floating World* is thought to be a series of some 20 prints. Another set of about 20 prints is inscribed *nihen* (second series, 二編), just like this example. The series without the word *nihen* illustrates various places, including Edo, Kyoto, Ise, Settsu and Mikawa, along with women, local *riyō* (folk songs) and *hauta* (songs sung to the shamisen). By contrast, the places depicted in the series inscribed *nihen* are all in Edo, though the locations and women's social standing are not indicated.

In this print, a woman, who seems to be the mother, is tying the child's hair into the *keshibō* style. In the Edo period, seven days after its birth, a baby had its hair shaved and, when it reached the age of three, the *Kamioki* Ceremony took place on the 15th day of the 11th month. From this day onwards the child's hair was allowed to grow, and at some point, all the hair was shaved off except certain parts in order to make the *keshibō* hairstyle, a practice which was also carried out by some commoners.

Although wearing a kimono with a plum blossom design, the child in this print may be a boy. The woman, probably his mother, is holding a *tokikushi* comb in her mouth and her hair is likely in the *warikanoko** style. Her *obi* is black, and the kimono with a pine-grove pattern also has five crests of three wild geese, with their heads facing outward. Next to her is a dressing table whose drawer reveals *motoyui* strings, a *kesujitate* comb, *nigiri-basami* scissors and so forth, while Bien Senjokō white face powder is placed on the floor.

The inscription at the top of the print is a verse relating to love and sentiment, while the vertical fan-shaped inset appears to illustrate a high-class restaurant, possibly in Yanagibashi. It would be interesting to identify the exact location, as well as the social status of the woman.

* *Warikanoko* is a hairstyle with the topknot separated into two loops shaped like a sideways '8' and with a hair stick thrust through the loops.

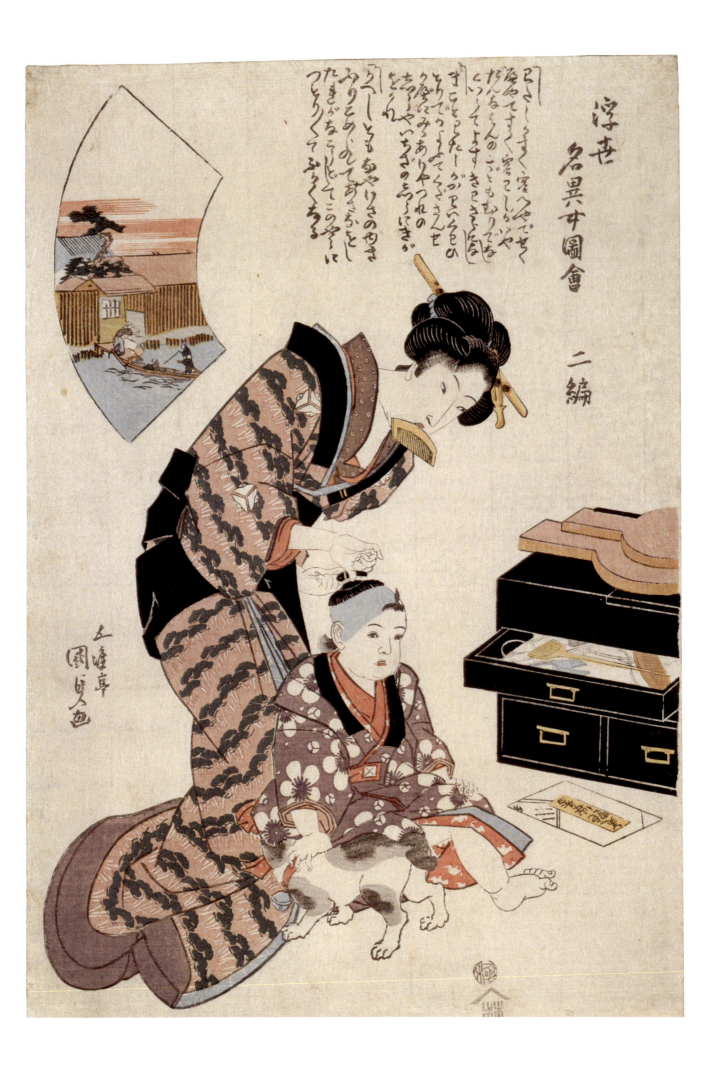

Chapter 2

Fashion in the Edo Period

Courtesan Fashion — 7 *ukiyo-e*

Fashion of Edo Women — 5 *ukiyo-e*

Brides' Fashion — 4 *ukiyo-e*

Fashion in the Edo Period

The leaders of fashion during the Edo period (1600-1868) were courtesans and Kabuki actors. Courtesans, in particular, were always at the cutting-edge of fashion in order to maximise their beauty. This is manifested not only in their make-up and hairstyles, but also in their clothing. In addition to the fashion of courtesans, existing *ukiyo-e* are the only evidence of women's traditional clothes, make-up and hairstyles based on their social status and class in their settings. Furthermore, as rare examples, wedding scenes are also introduced in this section.

The Courtesan Otaka of Maruebi-ya House, Views of Mt. Fuji from Various Provinces, a View from the Capital

Maruebi-ya nai Otaka, shokoku Fuji zukushi, miyako no Fuji

丸海老屋内　おたか　諸国冨士尽　都之冨士

Ippitsuan Eisen
一筆菴英泉

ca. Bunsei (1818-30) – Tenpō (1830-44) eras
文政～天保頃

Hikkomi shinzō Otaka

The Maruebi-ya mentioned in the title was the name of the brothel located at 1-chōme, Edochō. Otaka, the woman depicted here, has her hair in the Shimada-*mage* style, with the root of the topknot tied high. The hair is decorated with a comb larger than the topknot, a *ryōten-kanzashi* in the shape of peonies, three pairs of hairpins with ivy decoration inserted on either side, another pair inserted vertically near the topknot, and two more pairs into her hair at the front, with a total of 12 hairpins in all. Although the flamboyant hairstyle is typical of a courtesan, the fact that she is wearing a *furisode* (swinging-sleeved kimono) with a chrysanthemum design, suggests that she still feels like a girl. Her *obi* is tied in the *tatemusubi* (vertically-tied) style, and seems to be decorated with the cloud and butterfly motif of the *yūsoku-mon* crest.

It is said that a courtesan whose name begins with 'o', as in Otaka, was often a *hikkomi shinzō*, an apprentice to be a high-rank courtesan. According to the book *Yoshiwara saiken nenpyō* (Chronology of Yoshiwara guidebooks), edited by Yagi Keiichi and Niwa Kenji (1996), "In Yoshiwara brothels, a *kamuro* was known as *hikkomi kamuro* when she was preparing to be a *shinzō* or *heyamochi* (courtesan having her own room), living in the room of her mistress to learn entertainment skills. She then became a *shinzō*, and before *tsukidashi* (making her debut), she was called a *hikkomi shinzō*." There was also a *senryū* (witty, satirical poem) which reads: "Hikkomi to shōshi o no ji de hayaraseru (Calling (her) *hikkomi*, and making (her) popular with the *hiragana* 'o')", suggesting that Otaka was a *hikkomi shinzō*.

She may be practicing the *koto* (Japanese harp) behind her since there are books beside it. We can also see a packet of Bien Senjokō white face powder on the floor.

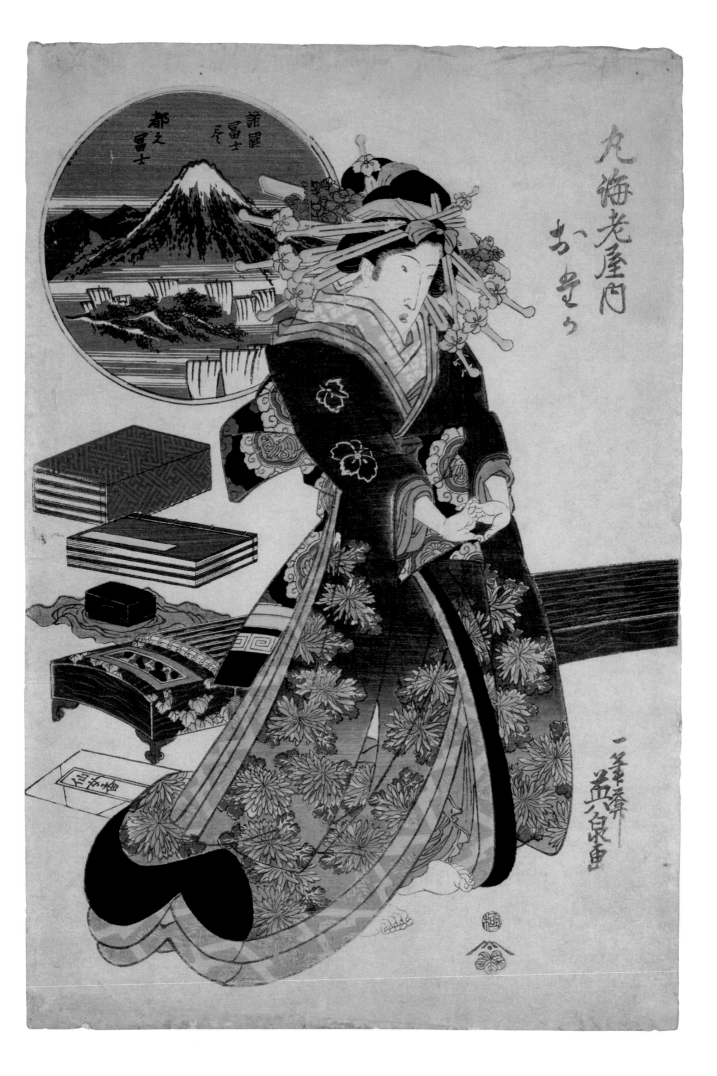

An Excellent Selection of Thirty-six Noted Courtesans: The Story of Tamagiku

Meigi sanjūroku kasen Tamagiku no hanashi

名妓三十六佳撰　玉菊の話

Utagawa Toyokuni, on Commission
応需　歌川豊国

Bunkyū 1 (1861)
文久元年

New Tamagiku

The woman resting her hands on the mouthpiece of the long pipe decorated with chrysanthemums is probably the courtesan Tamagiku*. The tobacco tray, razor box and *ugai-chawan* are all decorated with chrysanthemum designs. She has a *yoko*-Hyōgo** hairstyle with a long, flat hair stick, and is having the nape of her neck shaved with a razor. Her kimono, which looks like a *yukata*, has a large pattern of *gyōyō* (harness accessory) and chrysanthemums.

The woman holding the razor is also likely to be a courtesan, with her *obi* tied carelessly. The woman on the right may be a *furisode shinzō***. She wears a kimono with a bush warbler on a plum tree, and is holding a mirror-case and a dressing table decorated with a design of eight-petalled chrysanthemums and scrolls. Her hair is in the Shimada-*mage* style with a short forelock, while her *obi* reveals a hexagonal pattern.

On the left is a kimono with a design of peonies and *misu* (bamboo blinds), which is hanging over a folding clothes-rack that is painted with a chrysanthemum. The sliding doors visible behind the inset on the right also bear a chrysanthemum design – such a profusion of chrysanthemums throughout this print.

The text in the inset is by Santei Shunba, possibly alluding to the fleeting life of a courtesan.

The story of Tamagiku referred to in the title does not appear to be that of the noted courtesan Tamagiku of Nakamanji-ya at Sumichō, whose life was taken by sake at the young age of 25 in Kyōhō 11 (1726). Probably there were many courtesans who used the name Tamagiku; this one appears to be tough – a new type of Tamagiku.

* The name includes the word 'chrysanthemum' (*kiku* or *giku*).

** *Yoko*-Hyōgo is a hairstyle shaped like a butterfly which was typically favored by courtesans.

*** *Furisode shinzō* is an apprentice courtesan, so young as to wear *furisode*, or kimono with swinging-sleeves worn by young people.

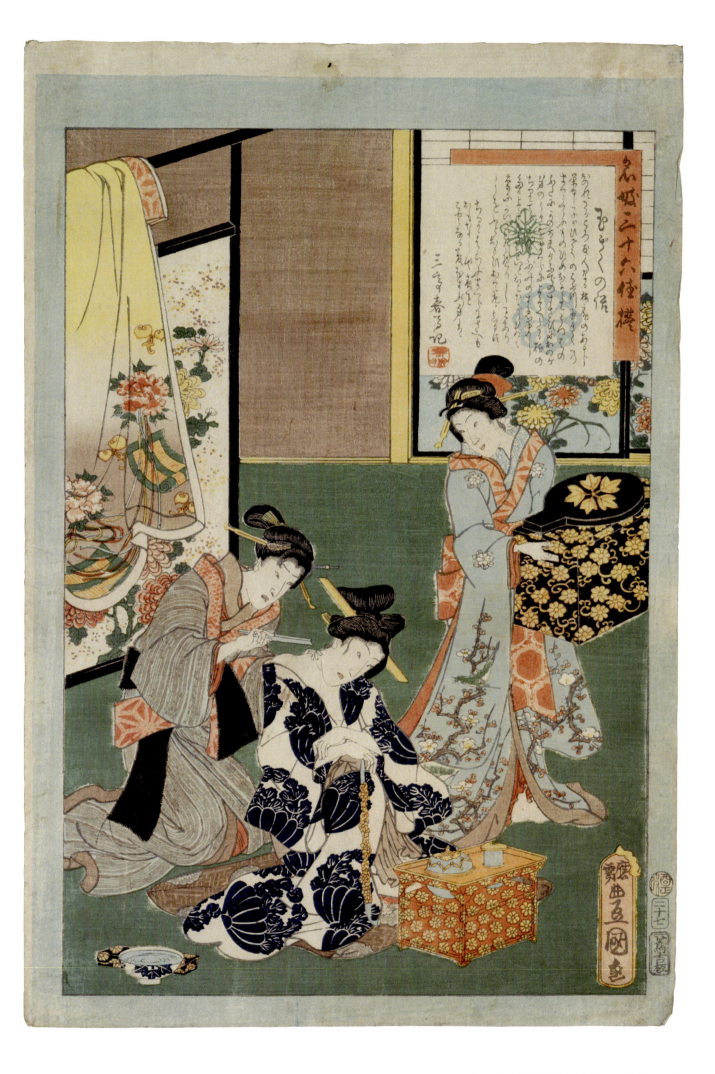

Chapter 2 Fashion in the Edo Period Courtesan Fashion 77

The Courtesans Asazuma, Hanamurasaki, and Tagasode of Tama-ya House in Edochō, Shin-Yoshiwara

Shin-Yoshiwara Edochō, Tama-ya nai Asazuma Hanamurasaki Tagasode

新吉原江戸町　玉屋内朝妻・花紫・誰袖

Utagawa Toyokuni
歌川豊国

Bunsei 10 (1827)
文政 10 年

Courtesans in their prime

After the Great Fire of Meireki (1657), the Yoshiwara pleasure quarters were moved to Asakusa and called Shin-Yoshiwara. In the Shin-Yoshiwara, there was a brothel named Tama-ya at 1-chōme, Edochō, and these prints depict three courtesans who worked there.

While the guidebook *Yoshiwara saiken* of autumn Bunsei 9 (1826) lists Hanamurasaki and Asazuma (both indicated as '*yobidashi*, day and night, *kin* 3 *bu*'), there is no mention of Tagasode. The *Yoshiwara saiken* of spring Bunsei 10, the following year, lists all three, including Tagasode ('*yobidashi*, day and night, *kin* 3 *bu*'). In the same publication of autumn Bunsei 11, Hanamurasaki remains as '*yobidashi*, day and night, *kin* 3 *bu*', whereas Asazuma and Tagasode have been demoted to 'day and night, *kin* 2 *bu*'. Asazuma and Tagasode may have been redeemed and taken over by others. If so, these prints are likely to date from around Bunsei 10 (1827) when the three courtesans were in their prime.

Hanamurasaki depicted in the middle reveals *yoko*-Hyōgo, a distinctive hairstyle among courtesans, while Asazuma and Tagasode have the Shimada-*mage* style. They all use hair ornaments made of tortoiseshell – a pair of combs, a hair stick, four pairs of hairpins in front and another four pairs at the back – with the exception of Hanamurasaki who has an additional pair of hairpins. They also have blackened teeth, which was a sign of chastity to their customers. Asazuma, on the left, is wearing an *uchikake* (long overgarment) with a design of flowers of the four seasons in fan-shaped cartouches and a *manaita-obi** with a bamboo design. Hanamurasaki, by contrast, wears an *uchikake* with a swallow design and an *obi* with motifs of *yūsoku-mon* tied in a style similar to that called *bunko-kuzushi*. The black padded hem of her *uchikake* is most probably velvet, as one can make out the pile. Tagasode on the left is wrapped up in an *uchikake* over her *obi*, the *uchikake* bearing a design of an encircled flower rhombus and a pattern of *hōju* (wish-granting jewel), which was the crest of Tama-ya.

Although this set is here presented as a triptych, it might also be a pentaptych. The reason being that the title box is missing, and the paper lanterns on either side are cut in half vertically. It makes us eager to see the complete set somewhere, someday.

* *Manaita-obi* (lit. cutting board sash) is tied at the front with the ends hanging down.

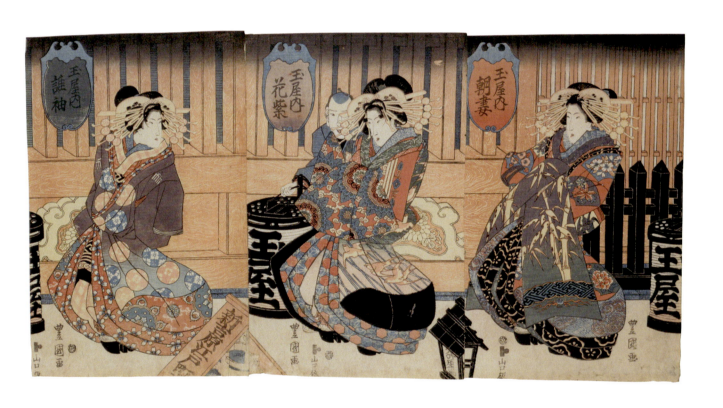

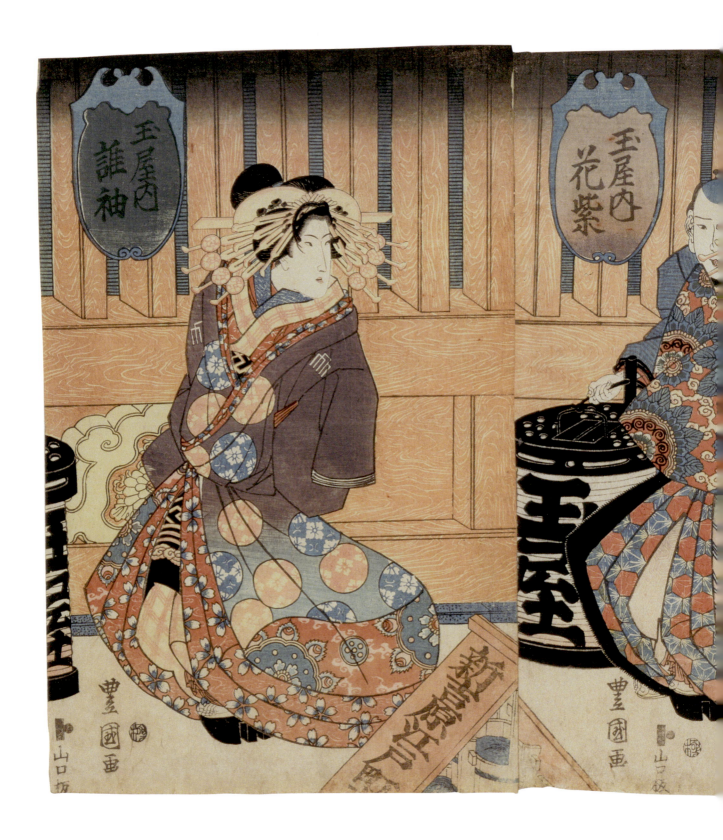

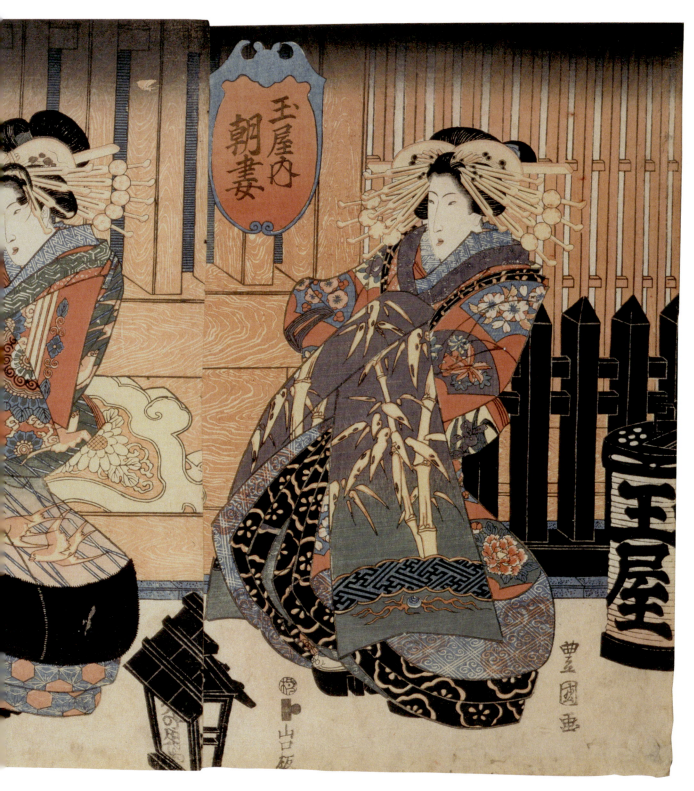

The Courtesans Asazuma, Hanamurasaki, and Tagasode of Tama-ya House in Edochō, Shin-Yoshiwara

Biographies of Famous Women, Ancient and Modern: Hakidame Omatsu

Kokon meifuden, Hakidame Omatsu

古今名婦傳　掃溜於松

Utagawa Toyokuni
歌川豊国

Bunkyū 1 (1861)
文久元年

Talented woman in a garbage heap

The woman posing in front of the mirror is the prostitute Hakidame (lit. garbage heap) Omatsu of a *tsubonemise* (brothel with the lowest-rank prostitutes) in Mita, Shiba. Her hair is arranged in the *bai-mage* style with her hair cut short at the front. She may have just finished her make-up, as we can see an *ugai-chawan* and a tufted toothpick by the black dressing table. She is wearing an *obi* with a hemp-leaf pattern, and a kimono with undyed patterns of stylized waves and interlocking swastika in patchwork-style cartouches shaped as cherry blossoms, pine, *matsukawabishi* and so forth.

The upper inscription is a text about Omatsu by Ryūtei Umehiko, who is not known for certain, but he may be Yomono Umehiko, a writer of popular literature from the end of the Edo to Meiji periods (1868-1912), and also a follower of Ryūtei Tanehiko I.

Although the total number is unclear, the *Biographies of Famous Women* is a series that includes 'Ono no Komachi', 'Tomoe Gozen (Lady Tomoe)' and 'Tokiwa Gozen (Lady Tokiwa)', as well as '*Yaoya* (lit. greengrocer) Oshichi', 'Yūgiri of Shinmachi' and 'The Courtesan Jigoku'.

This print indicates that there was a woman who was highly cultured despite being a prostitute of the lowest rank, while the name Hakidame Omatsu alludes to the expression '*hakidame ni tsuru* (a crane in a garbage heap)', meaning 'a jewel in a dunghill'.

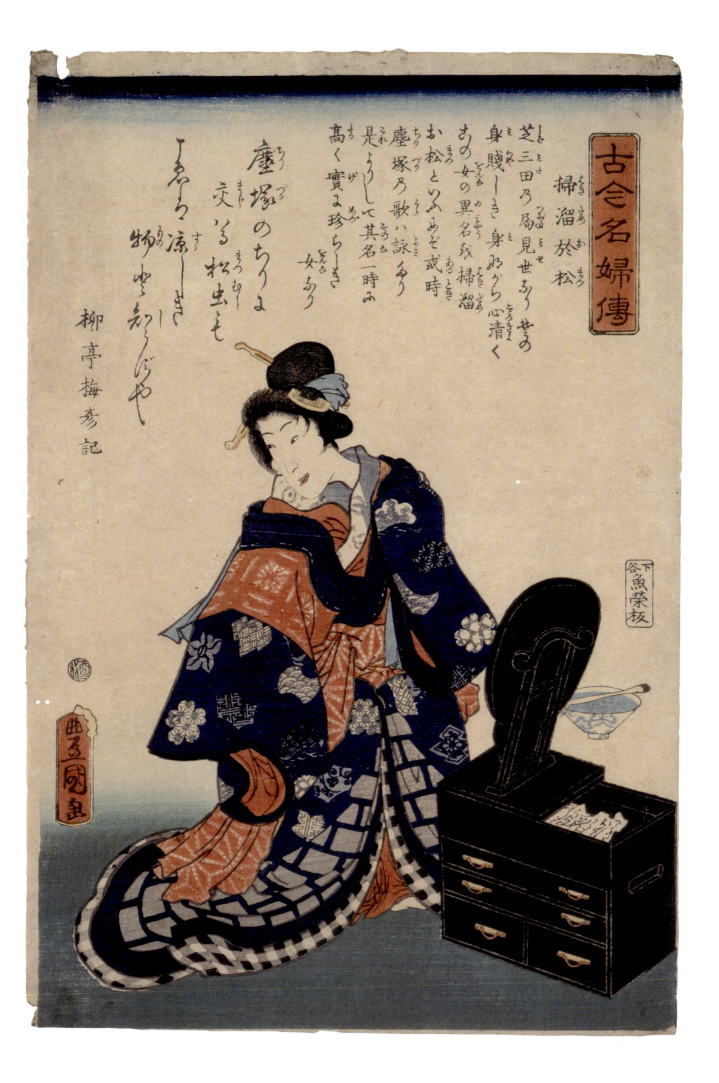

The Twelve Hours of Spring Pleasures: Hour of the Tiger
Haru asobi jūni toki, tora no koku

春遊十二時　寅ノ刻

Utagawa Toyokuni
歌川豊国

Ansei 3 (1856)
安政 3 年

Midnight transfer

This woman holds *misugami* paper in her mouth and has a *tenjin-mage* hairstyle, as well as a hairpin decorated with a dragonfly. She is likely a courtesan, and is taking a quick look at the clock. Is she in the middle of *mawashi*, a courtesan visiting multiple customers one after the other during the night, and having finished with one customer, goes on to the next? She seems to be indoors rather than out since she is wearing a pair of *zōri* sandals which appear to be *uwa-zōri* (indoor sandals). She is wearing a dressing-gown with a *nikuzushi* pattern, with the plaid borders appearing to frame the gown, giving the atmosphere of an unlicensed pleasure quarter.

This print was designed in Ansei 3 (1856) and, on the 2nd day of the 10th month of the previous year (Ansei 2), the Great Ansei Earthquake occurred, during which the Yoshiwara burned down. Taking this into consideration, the Yoshiwara may have been operating from *karitaku* at that time, temporary brothels licensed in residential areas of commoners whenever the Yoshiwara burned down.

The Yoshiwara was, in fact, completely destroyed by fire on many occasions. Each time this happened, the shogunate licensed temporary brothels in areas such as Asakusa and Fukagawa until the Yoshiwara was rebuilt. Not only were these temporary ones close to downtown and hence easy to visit, but at the same time, they did not bother about formality. As a result, it is said that their income increased and the *karitaku* managers were pleased.

The inset of this print probably depicts the watchman of a brothel using wooden clappers, alerting people to 'Look out for fire', as well as telling the time around the hour of the tiger (around 3 am to 5 am). At night courtesans were busy working with no time for sleep.

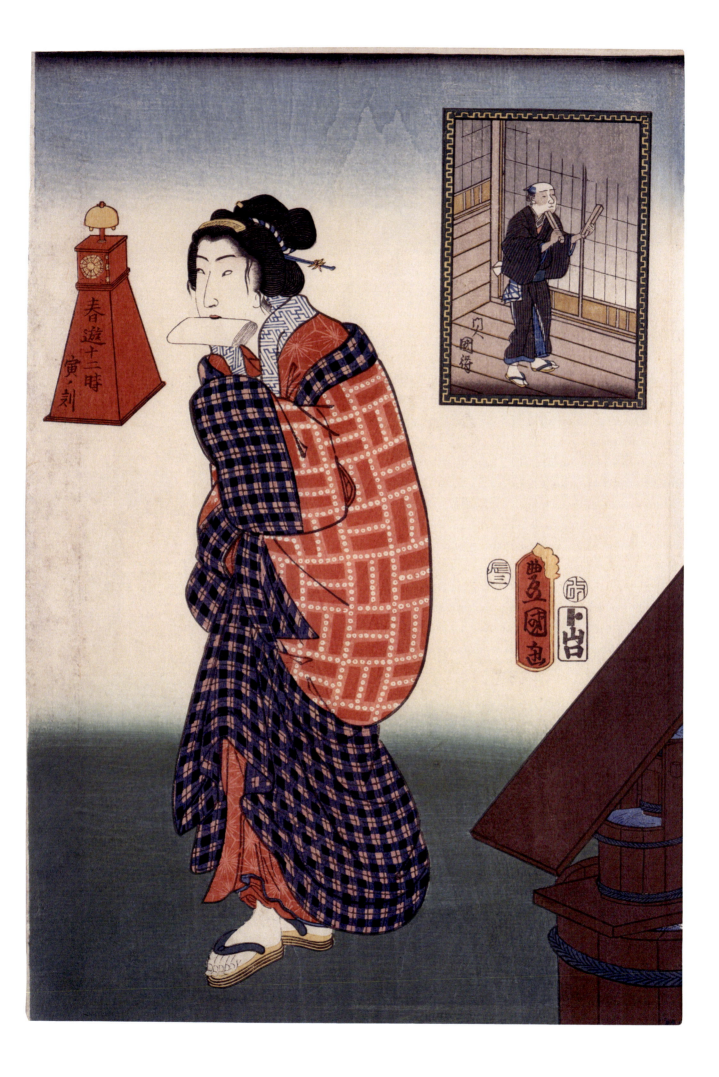

Chapter 2　Fashion in the Edo Period　Courtesan Fashion　85

Sixty-nine Stations on the Kisokaidō Road: Ageo, the Courtesan Takao of the Miura House
Kisokaidō rokujūkyū tsugi no uchi, Ageo, Miura no Takao

木曾街道六十九次之内　上尾　三浦の高雄

Ichiyūsai Kuniyoshi
一勇斎国芳

Kaei 2-3 (1849-50)
嘉永 2 ～ 3 年

The story of Sendai Takao

Takao was the highest ranking courtesan that belonged to Miura-ya Shirōzaemon of 1-chōme, Kyōchō, Shin-Yoshiwara, Edo. The name Takao was subsequently taken by as many as seven or eleven courtesans, one after the other, with the most famous being that of Takao II of Sendai.

She is known for the love letter "Kimi wa ima / Komagata atari / hototogisu (By now, have you / reached Komagata / Oh, little cuckoo!)" as mentioned in the *One Hundred Famous Places of Edo: Komagata-dō Hall and Azumabashi Bridge* by Utagawa Hiroshige, and it is also said that the lord of the Sendai domain, Date Tsunamune, redeemed her contract and killed her. Although this story may be fictional, it formed the basis of a number of plays, known as Takao-*mono,* that were created for Kabuki and *Jōruri*.

The inset in the shape of a maple leaf possibly represents the landscape of Ageo. The woman sitting on one of the scales in the guest room is Takao, while *senryōbako* (chests of gold coins) are on the other, illustrating a scene in the story in which Tsunamune, when redeeming or liberating Takao, paid as much money as her weight. The Ageo here is just a play on words – *age* in Japanese means 'lift up' or 'raise', and Takao is being raised on the scales.

Her kimono reveals a peony and peacock design, while her *obi* probably depicts a *yūsoku-mon* motif. Her hairpins are decorated with a maple leaf, which is associated with Takao.

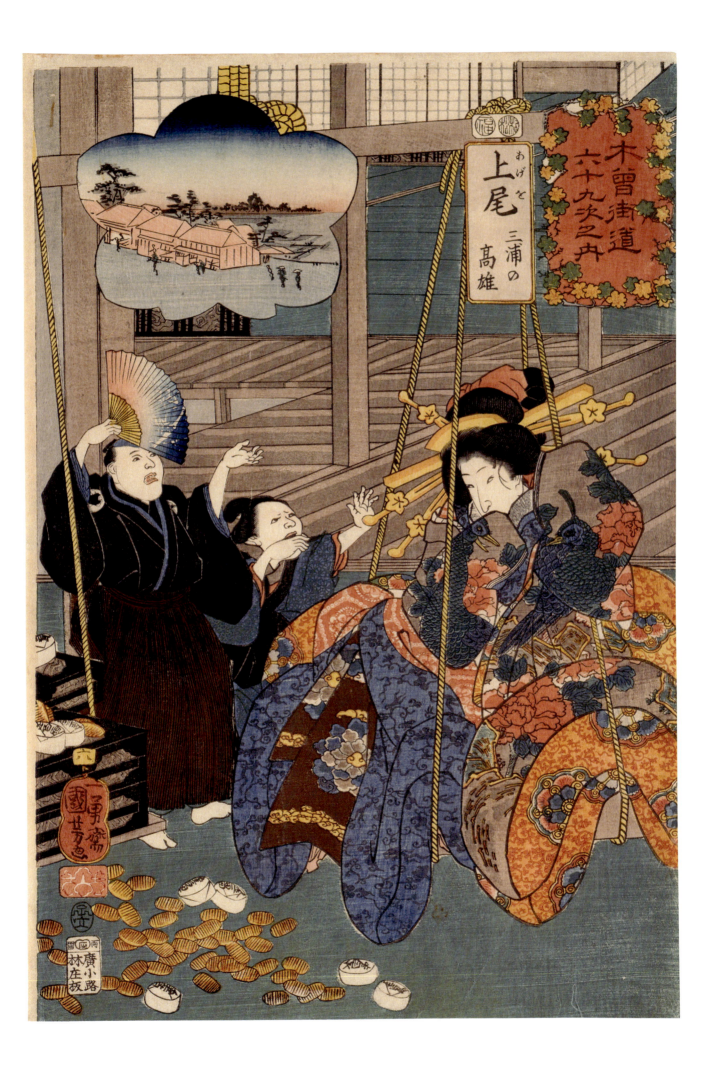

Scene of Lord Yorikane Redeeming the Contract of the Courtesan Takao of the Miura-ya House in Shin-Yoshiwara

Shin-Yoshiwara Miura-ya no Takao, Yorikane gimi miuke no zu

新吉原三浦屋の高尾　頼兼君みうけの図

Nagashima Mōsai
永嶋孟斎

Meiji 9 (1876)
明治9年

Sendai Takao and *senryōbako* (chest of gold coins)

Nagashima Mōsai who designed this print is also known as Utagawa Yoshitora. It depicts Takao being liberated, as in *Sixty-nine Stations on the Kisokaidō Road: Ageo, the Courtesan Takao of the Miura House*. In the hall of Miura-ya, Takao is on one of the scales while, on the other, Lord Yorikane has placed as much money as Takao's weight.

Takao is dressed in an *uchikake* with a design of a dragon and a tiger, while her *obi* is decorated with a maple leaf. Her hair is arranged in the *yoko*-Hyōgo style with a pair of combs.

The man on the right holding a sake cup in his hand is Lord Yorikane* who redeemed her. His kimono reveals a bamboo design, over which is likely a *hifu* (a kind of coat resembling a *haori*, but with a round neck and wider overlapping front panels) with a design of sparrows and snow-covered bamboo leaves. These are similar to the crest of the Date family, probably alluding to Date Tsunamune.

This was a big moment in Takao's life at the Miura-ya house, and the surrounding courtesans are enviously staring at her. This scene conveys her popularity as one of the best known courtesans of the Edo period.

The red color over the entire print is red aniline dye typical of *nishiki-e* (lit. brocade prints, or polychrome woodblock prints) of the Meiji period, while it also embodies the resplendence of a brothel. Interestingly, the lights hanging from the ceiling look like glass chandeliers. Although the story dates from the first half of the Edo period, the scene may be set around the late Edo to Meiji periods.

* The Lord Yorikane, or Ashikaga Yorikane, is a fictional character based on the lord of the Sendai domain, Date Tsunamune.

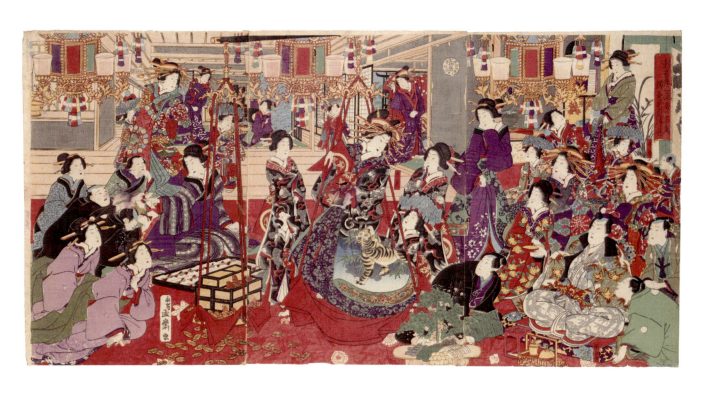

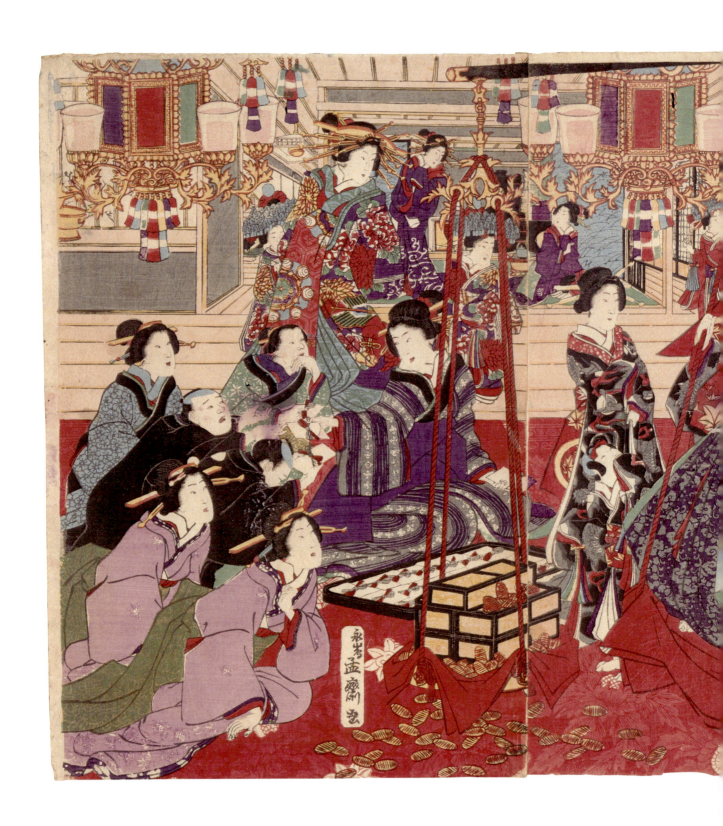

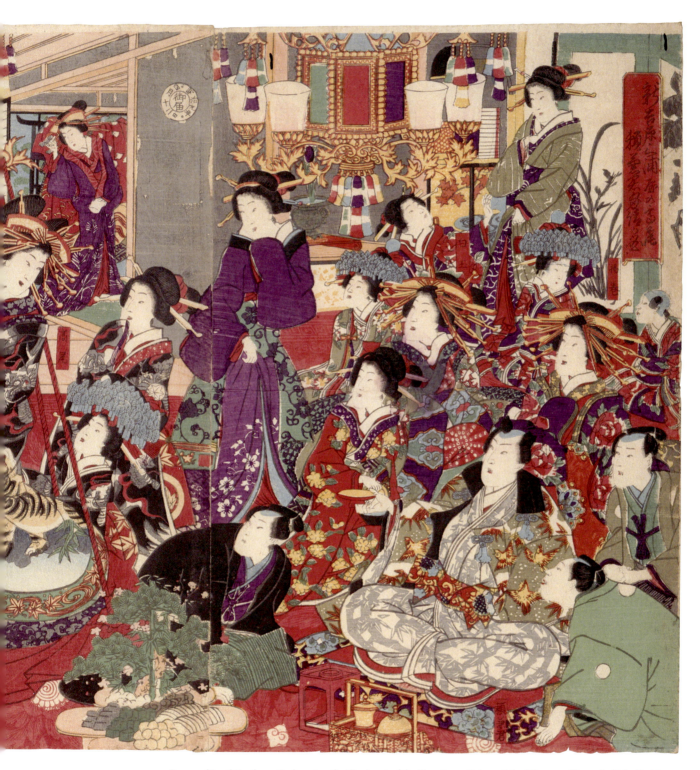

Scene of Lord Yorikane Redeeming the Contract of the Courtesan Takao of the Miura-ya House in Shin-Yoshiwara

Twelve Scenes of Modern Beauties: Tōeizan Kan'ei-ji Temple, Looking Pleased

Imayō bijin jūni kei, Tōeizan Kan'ei-ji, ureshisō

今様美人拾二景　東叡山寛永寺　うれしそう

Keisai Eisen
渓斎英泉

ca. Bunsei 5-6 (1822-23)
文政 5 〜 6 年頃

Palace maid visiting a temple on behalf of her mistress

The scroll-shaped inset depicts Kan'ei-ji temple in Ueno. Kan'ei-ji was Tokugawa's family temple and was famous for its cherry blossoms. The concept behind this print is that a palace maid visits the temple on behalf of her mistress.

Because she is going out of the palace for the first time in ages, she is carefully checking her appearance. She has a large Shimada-*mage* hairstyle and hairpins with flower decoration, as well as an *agebōshi*. The *agebōshi*, which was worn by palace maids and others when going out, is a headdress to protect the hair from dust. Held in her left hand is a hand-mirror that also contains toothpicks, which she is using to check her hair. Hanging from her mouth is what appears to be *kaishi* tissue paper; she is also wearing immaculate make-up.

Her kimono bears a design of Kōrin-style chrysanthemums, and the *obi* probably that of peony scrolls – a gorgeous and luxurious outfit suitable for a young woman. It is said that palace maids would enjoy viewing cherry blossoms or going to see a play after visiting the Kan'ei-ji temple on behalf of their mistress, which must have been exciting and enjoyable for them.

This series, *Twelve Scenes of Modern Beauties,* includes 'Amiable looking (*aisō ga yosasō*)', 'Pessimistic looking (*shinki sō*)', 'Carefree looking (*ku ga nasasō*)', 'Tomboy looking (*otenba sō*)', 'Obedient looking (*otonashi sō*)' and 'Quiet looking (*shizuka sō*)', portraying beauties from wives to young girls. Most of the beautiful women are wearing *sasairo-beni* (lit. rouge in bamboo-leaf color) that was popular around the Bunsei era (1818-30). Although the lower lip of the palace maid in this print is hidden by the *kaishi*, she is also likely wearing *sasairo-beni*, since the palace maid with the *katahazushi** hairstyle depicted in 'Quiet looking' is as well.

* *Katahazushi* is a typical hairstyle for high-rank palace maids.

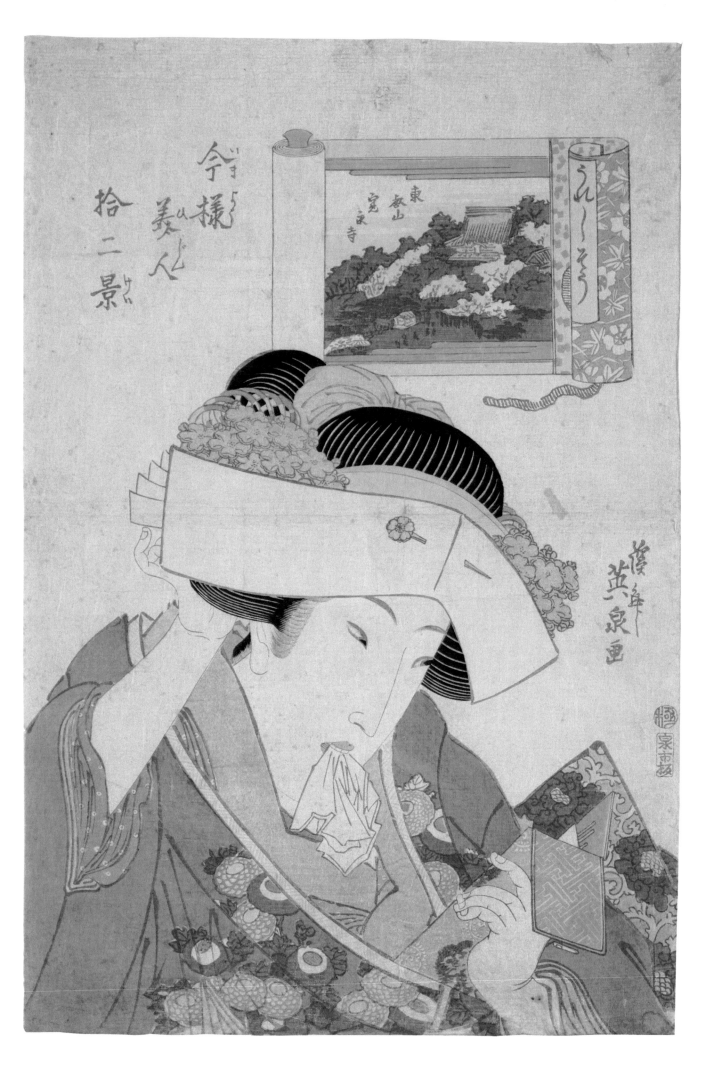

Flower Garden of the Four Seasons at Okuyama, Asakusa, Part III: Panoramic View of Plum-blossom Viewing

Asakusa Okuyama shiki hanazono kanbai enkei, sono san

浅草奥山四季花園観梅遠景　其三

Utagawa Toyokuni
歌川豊国

Kaei 5 (1852)
嘉永 5 年

Palace maids' *hanami* (blossom viewing)

This print appears to depict a scene of *hanami* at Okuyama, Asakusa, and the women portrayed here seem to be palace maids.

The one in the middle with an *agebōshi* headdress has blackened teeth and no eyebrows. Her hair is in *katahazushi*, a style typical of palace maids, and she is wearing an *uchikake* with a design of an arrowhead plant on a black ground. The woman next to her is probably a princess. She is wearing a magnificent outfit with a design of cherry blossoms and peonies, as well as large floral hairpins in her hair.

The woman on the left in a half-sitting position also has a *katahazushi* hairstyle, blackened teeth and no eyebrows. She is wearing a gorgeous *uchikake* with a chrysanthemum design, and an *agebōshi* on her head. The young woman on the right is probably beckoning to other maids who are coming down the hill.

This scene depicts a stroll in Okuyama, Asakusa, where the cherry trees are in bloom, and Mt. Fuji can be seen in the distance. Although the title box says 'plum-blossom viewing', we cannot see any plum blossoms, and the distant trees look more like cherry trees. Okuyama in Asakusa was an entertainment area with *misemono* (shows), restaurants, galleries for playing archery and so forth. Although it was possible to view cherry blossoms there, it is unlikely that palace maids would go to such a place.

This *Flower Garden of the Four Seasons at Okuyama, Asakusa, Part III: Panoramic View of Plum-blossom Viewing* is possibly a series by Toyokuni, as there is also a Part I, titled *Asakusa Okuyama shiki hanazono iriguchi kōkei, sono ichi* (*Flower Garden of the Four Seasons at Okuyama, Asakusa, Part I: Entrance View*). It depicts women of the pleasure quarters, such as Tatsumi geisha (geisha from Fukagawa) visiting Okuyama to see the cherry blossoms. It is possible that Toyokuni intended to depict women of different social status, thereby conveying the idea of the excellence of the four seasons of Okuyama.

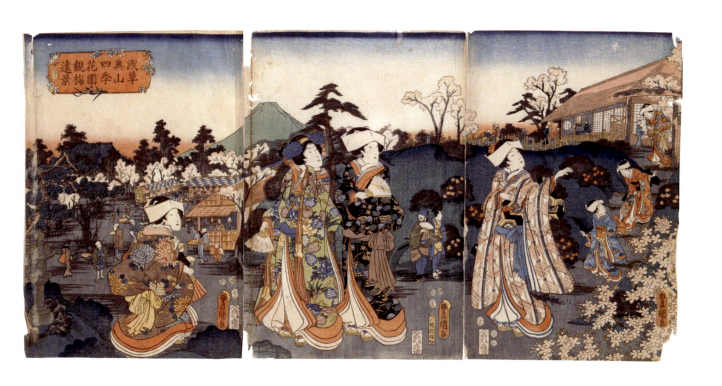

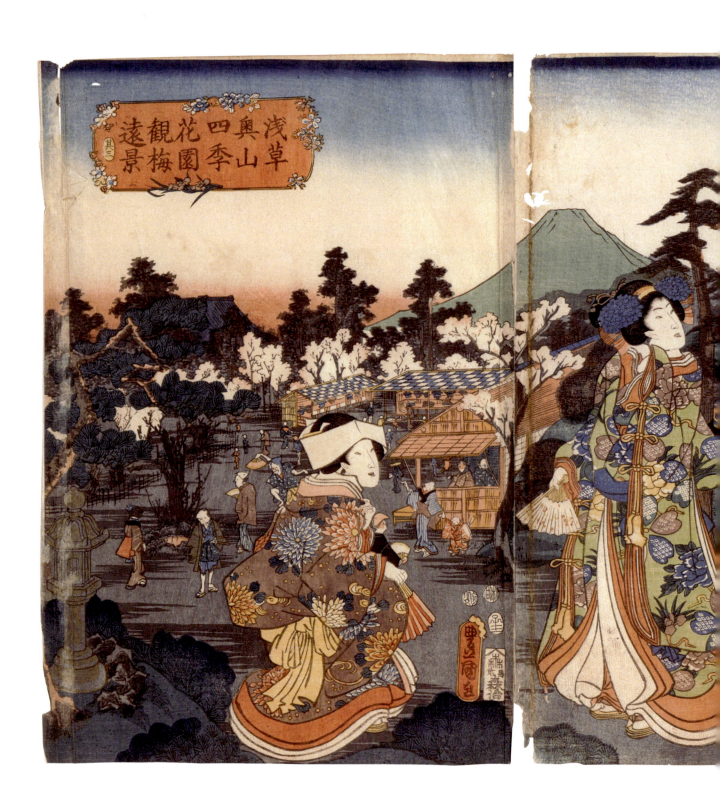

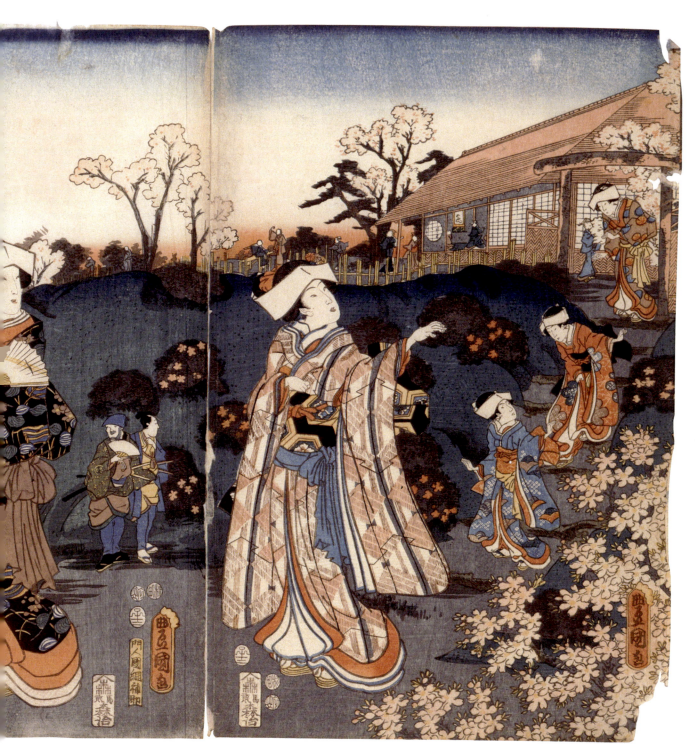

Flower Garden of the Four Seasons at Okuyama, Asakusa, Part III: Panoramic View of Plum-blossom Viewing

Modern Tale of Genji Picture Scrolls: Washing
Genji imayō emaki, arai

げんじ今様絵巻　あらひ

Utagawa Kunisada
歌川国貞

Ansei 5 (1858)
安政 5 年

Tub in the guest room

Naked from the waist upwards, the woman is having her neck washed over a tub. Her hair seems to be in a *fukiwa*, a style used by married women of the warrior class, and her blackened teeth are visible. The white *kosode* (kimono with small sleeves, and with small wrist openings) and *obi* with hexagonal pattern may suggest that she is a woman from a warrior family.

The tub, water pitcher, tray, and box for brushes and razors have a hollyhock-leaf design on black lacquer. The *kushidai* (comb chest) held by the young girl has the same hollyhock design, probably forming a set. On the *kushidai*, it is possible to make out such combs as *tokikushi*.

The young woman having her neck washed with a rice-bran bag is wearing a red kimono with a tie-dyed pattern and cherry blossoms. Her black *obi* with a design of a peony-like flower is tied in a *tatemusubi* style. Her hair is in a Shimada-*mage* style, into which is inserted a hairpin bearing flower ornaments, together with another hairpin with hanging decoration. The woman on the left with a *tsubushi*-Shimada hairstyle is holding a kimono with a design of hollyhock leaves, and is likely about to help in a change of clothes. The man on the right is dressed in a kimono with a design of symbols for incense based on the *Tale of Genji*. Again this man is probably Ashikaga Mitsuuji, the main character of *Nise Murasaki inaka Genji* (an unfinished bound volume) by Ryūtei Tanehiko. The man is wearing a *haori* coat with a crest of bamboo-style gentian.

The room has an alcove with a hanging scroll and folding screen depicting pine trees. Despite the apparently luxurious interior, the room does not have the atmosphere of a palace, or it could be a room in a brothel. We have no idea, because the women on the left seem to belong to one of the pleasure quarters, while the two women in the middle appear to be from the warrior class. An interesting thing about this print is that the grooming is carried out in the guest room: was it customary to have one's body washed in such a way?

People look worried as to whether the water would spill. This is indeed a mysterious picture.

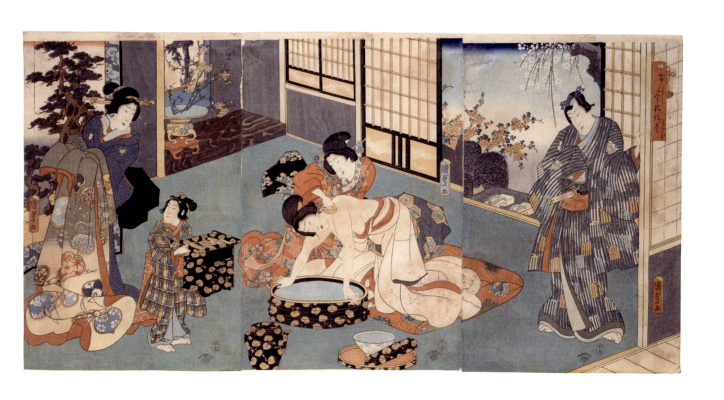

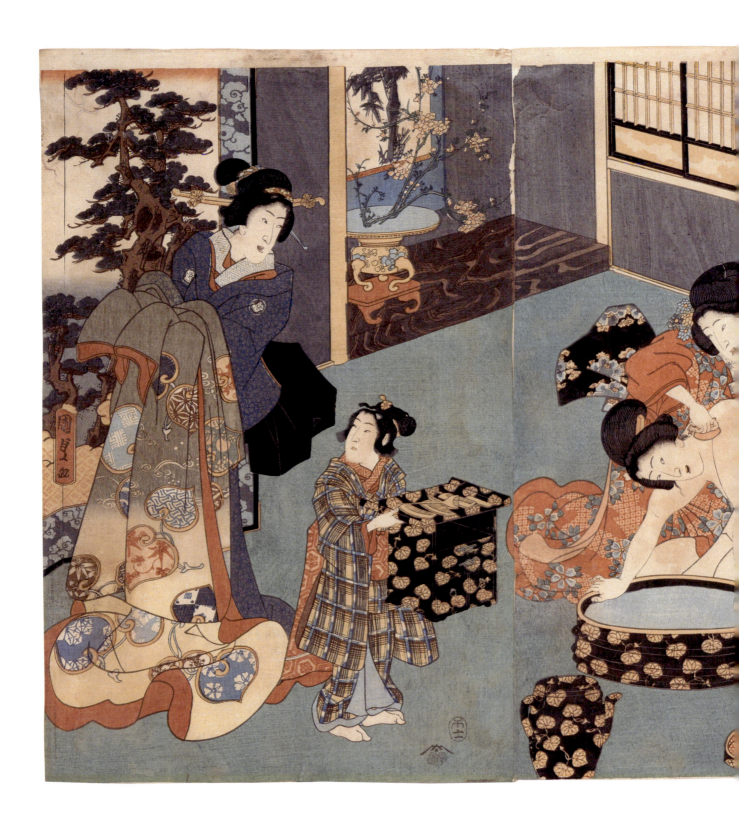

Modern Tale of Genji Picture Scrolls: Washing

The First Day of the Hare Festival at Kameido
Kameido hatsuu matsuri

亀戸初卯祭

Utagawa Toyokuni
歌川豊国

Ansei 1 (1854)
安政元年

Three beauties of Edo

Depicted behind the three beauties is the Kameido Myōgisha shrine located in the precinct of Kameido Tenmangū shrine. A festival was held on the day of the Hare every month, and the first day of the Hare in the New Year was particularly bustling with visitors. Visitors to the shrine were given a talisman to ward off evil, which they inserted into a bamboo pin, and put it into their hair. This talisman is said to protect against lightning.

The woman on the left has the talisman inserted into her *obi* with a design of a hare in a floral roundel tied at the front, worn under a striped *hanten* (coat), while holding a *nobe-kiseru* (metal smoking pipe) in her hand. Likely being married, she has blackened teeth and possibly a hairstyle called *kōgai-mage* with a hairpin decorated with *daruma*.

The young woman in the middle may be a girl from a warrior family. She has a Shimada-*mage* hairstyle with a large decoration of *fukura-suzume* (stylized sparrow). Her kimono has a design of the characters pronounced *yoki* (世紀) as well as *kotoji* (harp tuners) and *kiku* (chrysanthemums), serving as a riddle meaning '*yoki koto o kiku* (hearing good news)'. Her *obi* is of a *shokkō-mon* pattern (octagons and squares) tied in a *tatemusubi* style. Some chains of a *hakoseko* pouch can be seen at her chest.

Is the chic woman on the right a geisha? She has *tsubushi*-Shimada style hair inserted with a hairpin decorated with *mayudama*, a souvenir of the First Day of the Hare Festival. Her inner kimono, whose front hems are somewhat folded back on either side, has a design of a net and Chinese lantern plant. Her black outer robe has a design of a Chinese lantern plant and the crest of *kukuri-saru* (toy monkey). At her chest is a case for *kaishi* tissue, and her *obi* is likely tied in a style called *tsunodashi*.

Despite their difference in social status and class, the three women are portrayed with appropriate outfits, hairstyles and hair ornaments. Each seems to be enjoying the festival, the three are indeed beautiful and relaxed.

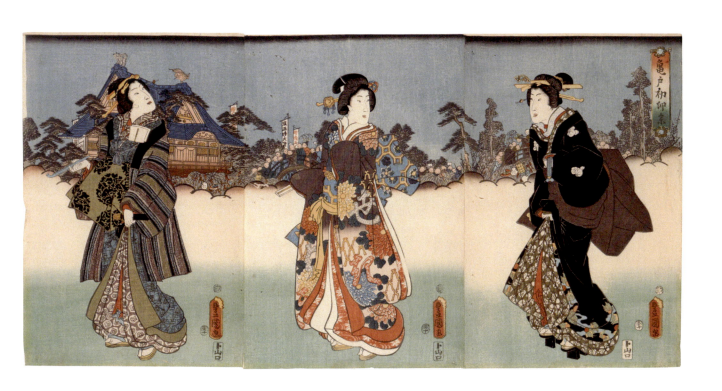

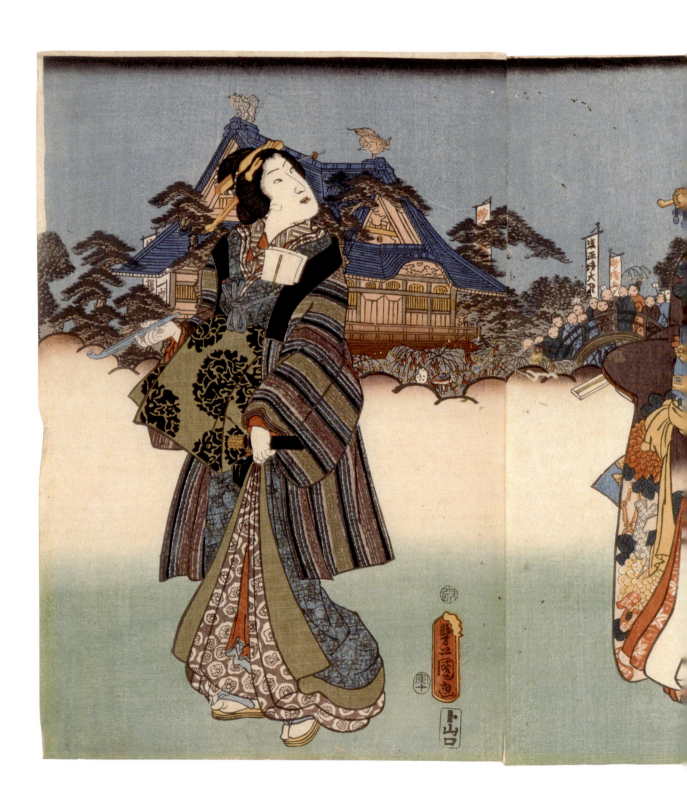

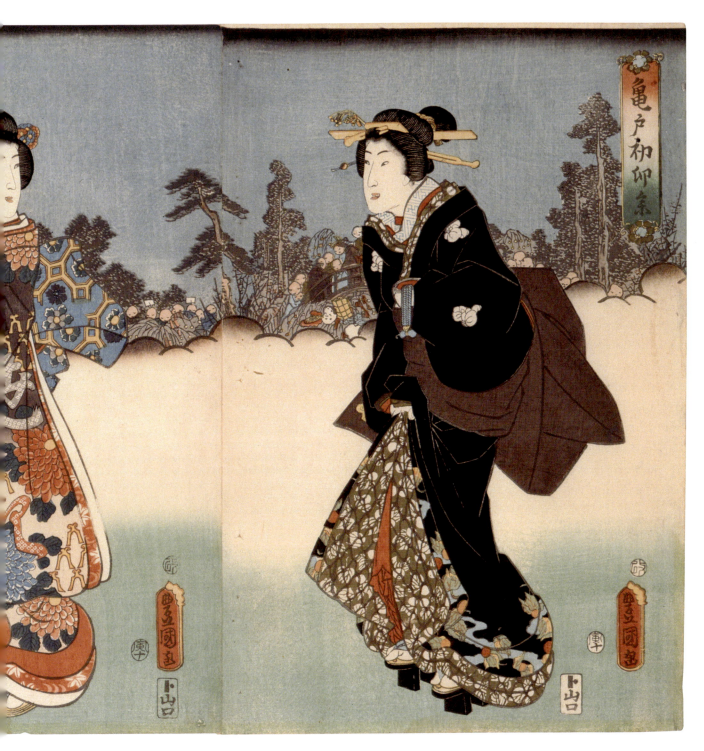

The First Day of the Hare Festival at Kameido

Modern Chrysanthemum Varieties: Drinker
Imayō kiku soroi, hidari ga kiku

時世粧菊揃　左りがきく

Ichiyūsai Kuniyoshi
一勇斎国芳

Kōka 4 (1847)
弘化 4 年

A heavy drinker unlike a woman

 Associated with the word *kiku*, this print is in the same series as *Modern Chrysanthemum Varieties: Hearing Good News in the Morning*. 16 prints of this series have been identified to date. Is the word *hidari* (lit. left) 左り in the title the same as *satō* 左党, which means a drinker?

 Her loose hair is in a style called *jiretta-musubi*. Some parts of hair along the hairline have also come loose; she is probably a woman of low rank. With a sake cup in her right hand, her gesture may indicate that she cannot drink any more. She may be a heavy drinker, unlike most women and, at the moment, might be competing with a man in drinking.
She is in a kimono with a plaid pattern and an *obi* with a design of chrysanthemums and bellflowers, possibly tied in a style called *koman-musubi*. We see disposable chopsticks and food in a container, which may be a side dish for sake. Low rank as she may be, her face is somewhat appealing.

 The upper part is inscribed with a text by Kunoya Baizen, who was also the *kyōka* poet Umeya. His family name was Morota, his given name Shōichi, and was commonly known as Ryūnosuke. He was possibly born in Kansei 9 (1797). Although he was four years younger than Kuniyoshi, he was deeply connected with him, contributing many *kyōka* poems to his prints. *Kyōka* poems by Umeya and others indeed bring the pictures of *Modern Chrysanthemum Varieties* to life. This is an interesting series, which tells us how viewers enjoyed them with a playful mind.

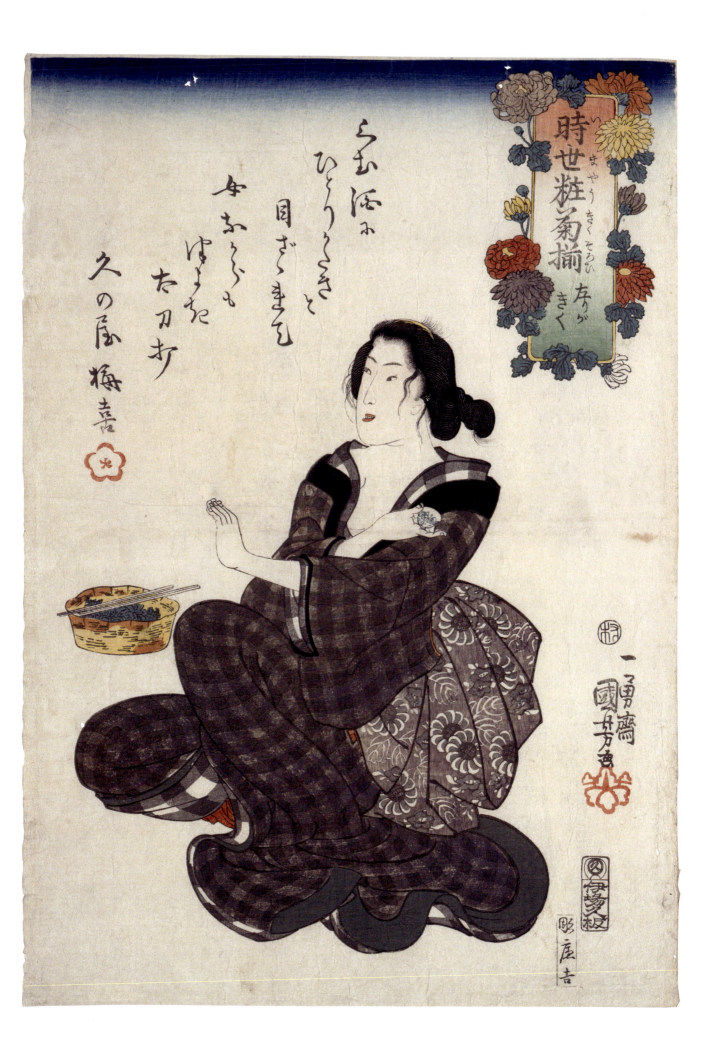

Three Rites: Wedding Scene

Santeirei no uchi, konrei no zu

三定例之内　婚禮之図

Ichiyūsai Kuniyoshi
一勇斎国芳

Kaei 1 (1848)
嘉永元年

Receiving a bride

Does the title *Santeirei no uchi* suggest that there are three rules in a wedding ceremony? The bride in *shiromuku* (long white garment) emerged from the palanquin that had been brought into the bridegroom's house, and her hands are taken by *machijōrō* (women who wait at the door for the bride's arrival for the wedding, lead her into the house by taking the bride's hands, and take care of her). They are probably about to go to the room where the wedding ceremony will take place. The bride is wearing a *kazuki* (kimono-shaped veil), under which red *takenaga* (paper strips) are showing at the edges.

The two *machijōrō* and the two women waiting on the left, the women on either sides of the palanquin and the two in a room far behind on the left, all have *katahazushi*, a hairstyle distinctive of palace maids. Some have blackened teeth with their eyebrows shaved off, suggesting that they may be of relatively high social status.

The bride's palanquin is decorated with floral scrolls in gold on black lacquer and, from the way the *misu* (bamboo blind), tassels and curtains look, she is apparently a princess of considerably high rank. The palace maids also wear gorgeous *uchikake* with tie-dyed or embroidered designs. Each with a smile on her face, they seem just as pleased as the bride.

Since, during the Edo period, *koshiire** usually took place in the evening (around 6 pm), many candles and candle stands can be seen all around the room.

The *shiromuku* is said to have the meaning 'to be dyed into the color of the husband's family', which conveys a sense of the purity and innocence of the bride.

* *Koshiire* (lit. entrance of the bride's palanquin) was a procession in which the bride was taken into the husband's household for the wedding.

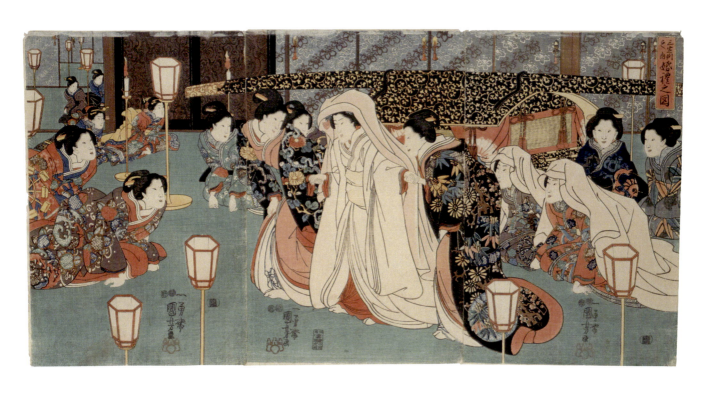

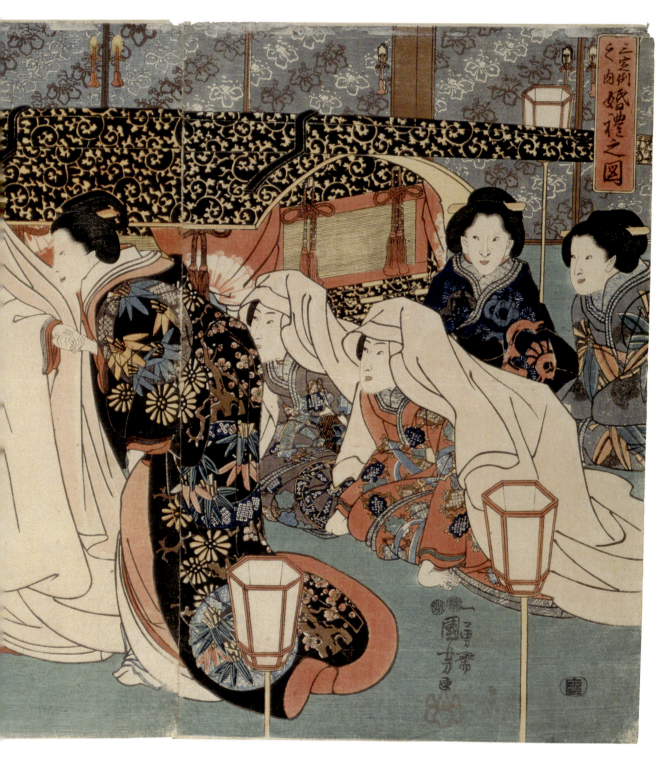

Three Rites: Wedding Scene

Wedding Scene in Genji-style Painting
Genji goshūgen no zu

源氏御祝言図

Utagawa Toyokuni
歌川豊国

Bunkyū 1 (1861)
文久元年

Kazunomiya (Princess Kazu) and Iemochi

With her hands held by the *machijōrō*, the bride has just entered the room where the bridegroom is waiting. Although she is wearing a *shiromuku*, her *obi* is magnificent with *yūsoku-mon* motifs. Her hair is in a style called *fukiwa* with a hairpin decorated with cherry blossoms, and the red *takenaga* strips add a touch of gorgeousness. Her mouth reveals blackened teeth, while her eyebrows are not yet shaved. Being shy, she is walking with her head hanging down.

Many of the women who look at the bride's face with their hands on the *tatami* floor have a *katahazushi* hairstyle. They are probably high-ranking palace maids, with blackened teeth and small eyebrows painted on the upper part of their forehead. Although palace maids usually keep their eyebrows shaved and did not paint them on, they did for a ceremony such as this.

Placed in the center is a splendid *shimadai* (lit. island table) with Takasago pine (miniature pine, bamboo, plum, old man and woman, crane, turtle and other auspicious items arranged to imitate Mt. Hōrai). On the small offering stand before the table is a *noshi-awabi* (a bundle of dried slices of abalone meat) for everlasting good wishes.

This print is one of the Genji-style pictures from *Nise Murasaki inaka Genji* (an unfinished bound volume) by Ryūtei Tanehiko, and the man on the left is probably the main character Ashikaga Mitsuuji. It was in Bunkyū 2 (1862) that Kazunomiya married the Shogun Tokugawa Iemochi. Although this scene was intended to be the wedding of the princess, since the depiction of the inner palace of Edo Castle was forbidden, it probably took the form of a Genji-style picture instead. Since this was the last ceremony of the Tokugawa shogunate, it is hard to imagine from this scene that a new era was just around the corner.

Due to fundamental impending political changes, the splendor of the scene somehow imparts a sense of fragility.

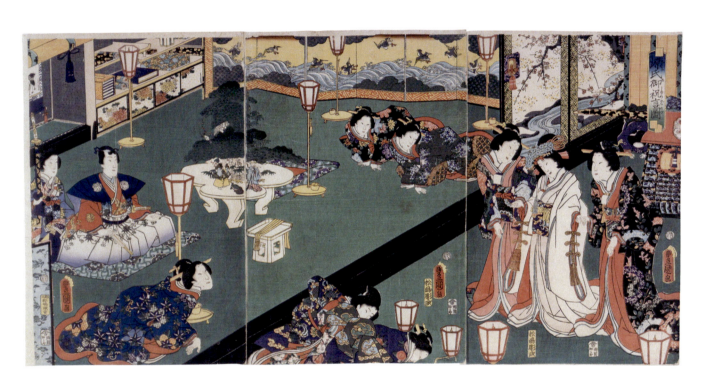

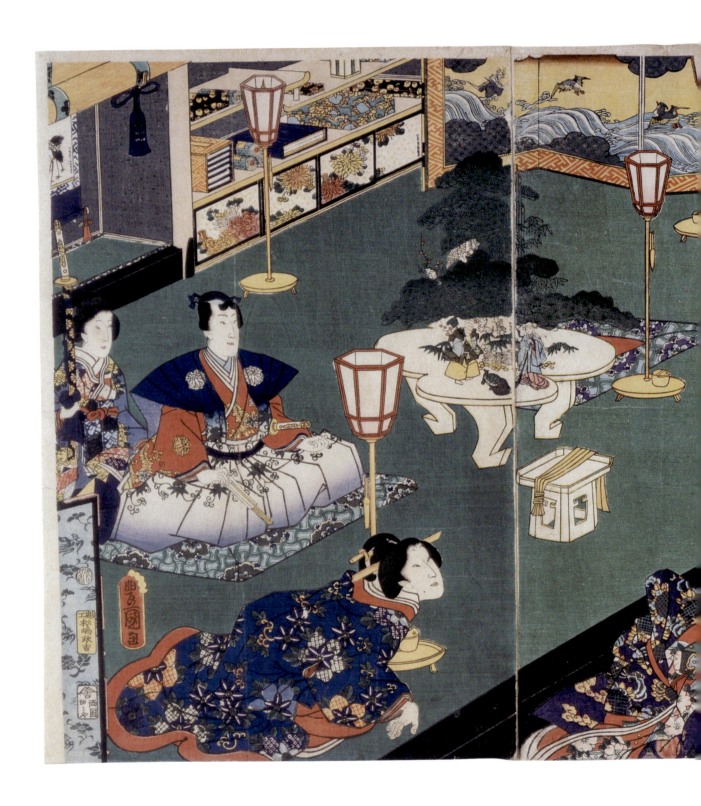

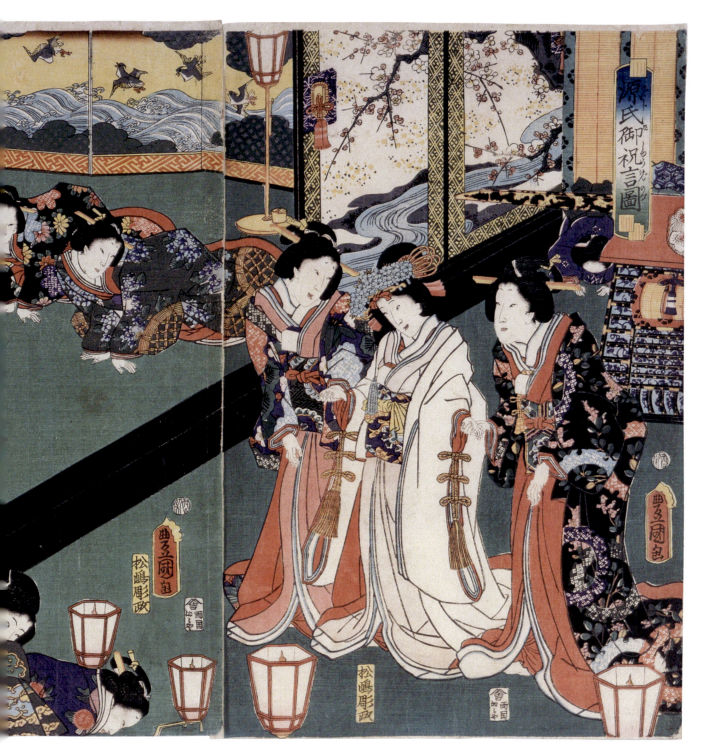

Wedding Scene in Genji-style Painting

Etiquette for Women: Wedding

Fujin shorei kagami no uchi, konrei

婦人諸禮鑑之内　婚禮

Ichiyūsai Kuniyoshi
一勇斎国芳

ca. Kōka era (1844-48)
弘化頃

Wedding of a merchant family

Unlike the scenes of an upper class wedding that we saw in *Three Rites: Wedding Scene* and *Wedding Scene in Genji-style Painting*, this picture is probably the wedding of a wealthy merchant family.

The bride in *shiromuku* has already blackened her teeth, and her hair is in a *maru-mage* style with large floral hairpins. The woman beside her, also with a *maru-mage* hairstyle, holds the bride's *uchikake* – is she a go-between? Her inner kimono has a pine-needle design, while that of her outer robe is of bamboo and plum with five crests of a pair of confronting wild geese. Her *obi* has a pattern of flowers and interlocking swastikas.

The young woman on the left with a Shimada-*mage* hairstyle holds a large mirror with the handle in its black mirror-case. She wears a kimono with a design of plums, cherries and maple leaves, as well as five crests with a side-view of chrysanthemums and embracing chrysanthemum leaves. Her *obi* has a pattern of Chinese flowers in a rhombus.

The woman on the right holding a kimono is wearing a different one with a design of symbols for incense based on the *Tale of Genji* and five crests of confronting butterflies. Her *obi* is decorated with *yūsoku-mon* motifs on an interlocking swastika ground. Her hairstyle is *ryōwa-mage**, a style for married women. The back part of her hair which sticks out is rather unusual in a scene from around the Kōka era (1844-48), the late Edo period, since this was a hairstyle popular in the mid Edo period.

The upper inscription is a text by Ryūkatei Tanekazu.

The large candles, gorgeous dressing table and containers for the Shell-matching Game make this wedding no inferior to one for the warrior class.

* *Ryōwa-mage* is a hairstyle for married women with two loops of hair, hence *ryōwa* (lit. both loops). This hairstyle is like a combination of the Katsuyama-*mage* and *kōgai-mage* styles.

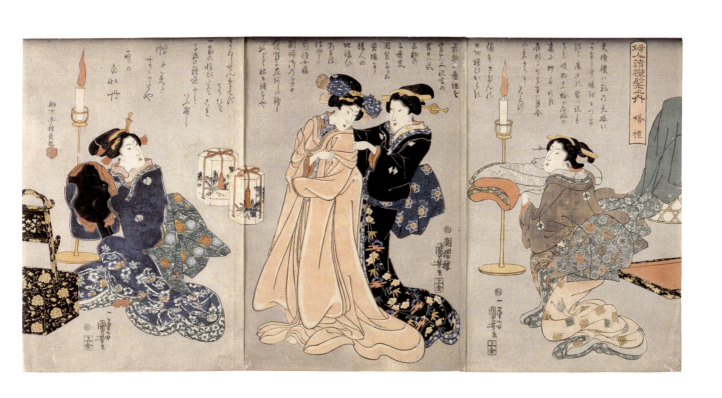

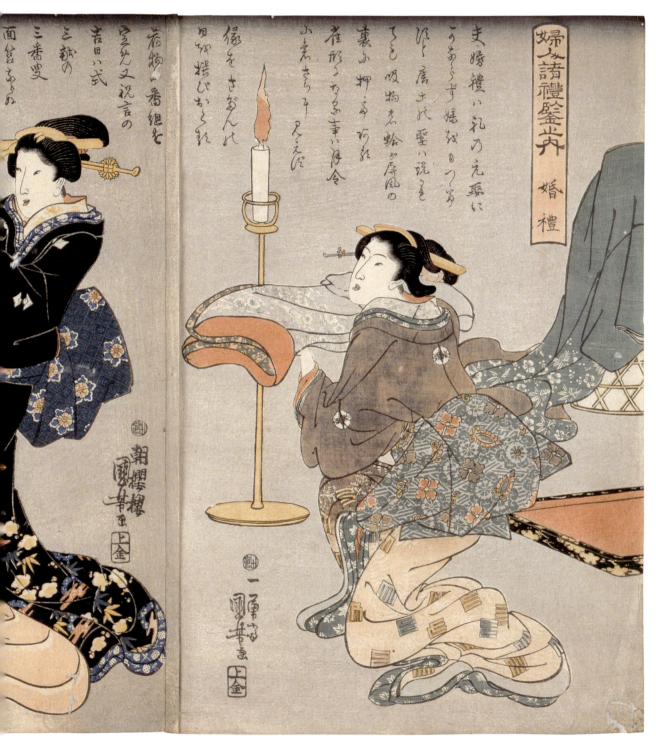

Etiquette for Women: Wedding

Scene of Bride's Change of Dress
Konrei ironaoshi no zu

婚礼色直し之図

Ichiyūsai Kuniyoshi
一勇斎国芳

Kōka 4 (1847)
弘化 4 年

Borrowing Utamaro's design

When the ceremonies of *shiki-sankon* and *sansan-kudo** were finished, the bride would remove the *watabōshi* (floss silk headdress), and change into a colored *kosode* given by the bridegroom's family. During the Muromachi period (1333-1568), the bride wore *shiromuku* for two days, while in the Edo period, there were some cases where the bride changed clothes as soon as the *shiki-sankon* ceremony was over.

Is the woman helping the bride in the middle a go-between? She has blackened teeth and no eyebrows. Her kimono in purple gradation is decorated with a chrysanthemum design along the hem, as well as five crests of paulownia. Her *obi* has a floral pattern with stylized waves, and her hair seems to be in *ryōwa-mage*, a style for married women. The women wearing a kimono with an apparent Edo-*zuma*-style** design and crests are all married, with *maru-mage* hair and blackened teeth.

Of the two young girls, one of whom is cutting a candle wick on the far left, while the other is holding her sleeve to cover her mouth on the far right, both have a *yuiwata* hairstyle with red *tegara*, while the *obi* is tied in a *tatemusubi* style.

Considering the sumptuous garments hanging on the clothes racks and folding screens, as well as the large mirror in the foreground, this is again the family of a wealthy merchant. The women surrounding the bride are chatting and squealing gaily, while taking care of her.

Since the composition of this print is almost identical to one of the same title by Utamaro, Kuniyoshi probably borrowed his design. It is said that the borrowing of designs in this way was not uncommon, while the women's faces in this print somewhat resemble those of the beauties depicted by Utamaro.

* *Shiki-sankon* and *sansan-kudo* are the formal ways of drinking (sipping) sake at a ceremony.

** Edo-*zuma* is a type of kimono design in which motifs are arranged in the front hem areas.

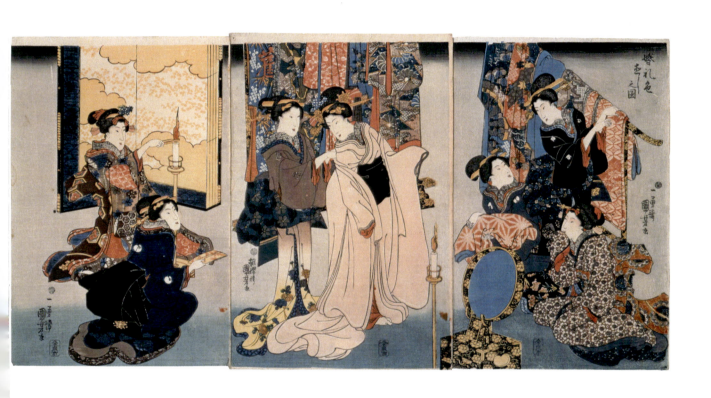

Chapter 2　Fashion in the Edo Period　Brides' Fashion　121

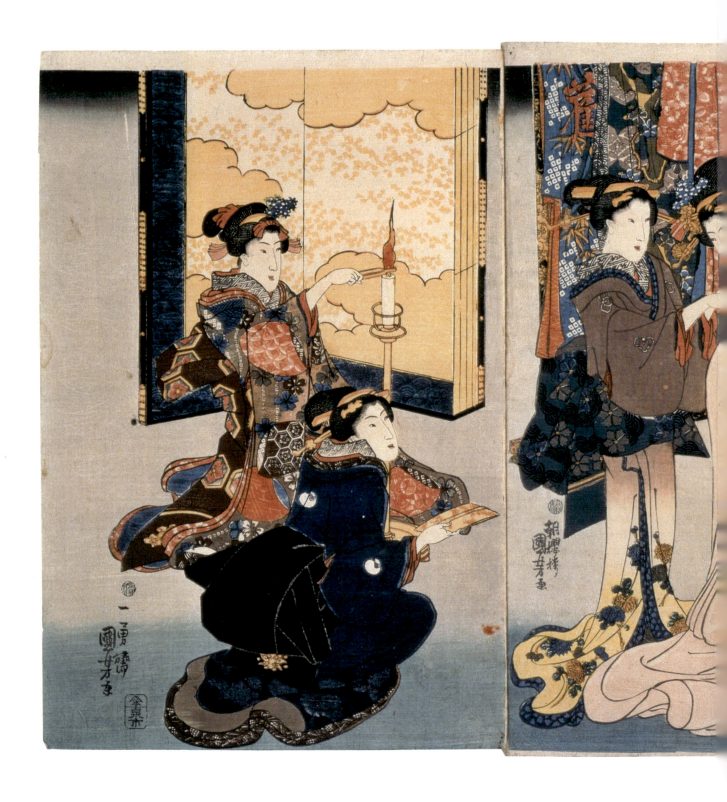

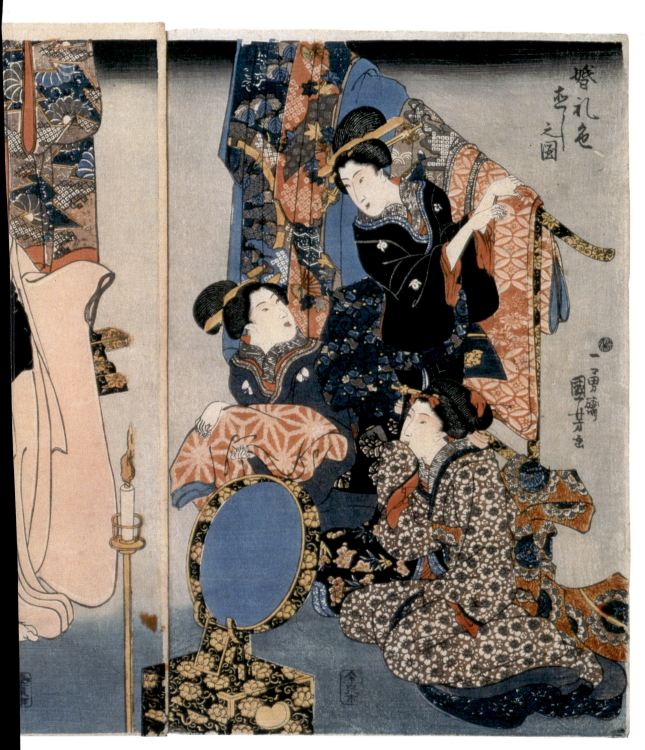

Scene of Bride's Change of Dress

Select bibliography (chronological order)

Abe Gyokuwanshi, *Tōsei kamoji hinagata* (Contemporary hairstyle examples), 1779

Sayama Hanshichimaru, *Miyako fūzoku kewai den* (Ways and customs of make-up in the capital), 1813

Kitagawa Morisada, *Morisada mankō* (Morisada's comparisons of the customs of Edo and Kamigata (Kyoto and Osaka)), 1837-53

POLA Bunka Kenkyūjo (POLA Research Institute of Beauty & Culture) and Tabako to Shio no Hakubutsukan (Tobacco and Salt Museum), eds., *Yosooi no bunkashi: Edo no onnatachi no ryūkō tsūshin* (Cultural history of fashion and make-up: fashion reports on women in the Edo period), POLA Bunka Kenkyūjo (POLA Research Institute of Beauty & Culture), 1991

Murata Takako, *Yuu kokoro: Nihongami no utsukushisa to sono katachi, Edo kara Meiji e* (The soul of hairdressing: the beauty and forms of traditional Japanese hairstyles for women from the Edo to Meiji periods), POLA Bunka Kenkyūjo (POLA Research Institute of Beauty & Culture), 2000

Fashion and Make-up of Edo Beauties Seen in *Ukiyo-e* Prints
The POLA Research Institute of Beauty & Culture Collection

Published on February 15, 2018 (First printing)
Edited by POLA Research Institute of Beauty & Culture
Price: 3,000 yen + tax

Written by	Murata Takako
English translation by	Komada Makiko
English text reviewed by	Julia Hutt
Published by	Konishi Takako
	POLA Research Institute of Beauty & Culture
	POLA ORBIS Holdings Inc.
	POLA No. 2 Gotanda Bldg. 1F, 2-2-10 Nishi-Gotanda,
	Shinagawa-ku, Tokyo 141-0031, Japan
	Tel. +81-3-3494-7250, Fax. +81-3-3494-7294
	http://www.po-holdings.co.jp/csr/culture/bunken/
	E-mail: infobunken@po-holdings.co.jp
Designed by	Oval Co., Ltd.
Printed by	Digital On-Demand Publishing Center

© POLA RESEARCH INSTITUTE OF BEAUTY & CULTURE
ISBN 978-4-89478-010-1　C0039　¥3000E

ポーラ文化研究所コレクション

浮世絵にみる江戸美人のよそおい【英語翻訳版】

2018年2月15日　初版発行
ポーラ文化研究所　編
定　価　（本体3,000円＋税）

著　者	村田孝子
英　訳	駒田牧子
英文校正	ジュリア・ハット
発行者	小西尚子
発行所	株式会社ポーラ・オルビスホールディングス
	ポーラ文化研究所
	〒141-0031　東京都品川区西五反田2-2-10　ポーラ第二五反田ビル1階
	電話 03-3494-7250　FAX 03-3494-7294
	http://www.po-holdings.co.jp/csr/culture/bunken/
	E-mail：infobunken@po-holdings.co.jp
デザイン	株式会社オーバル
印　刷	株式会社デジタル・オンデマンド出版センター

© POLA RESEARCH INSTITUTE OF BEAUTY & CULTURE
ISBN 978-4-89478-010-1　C0039　¥3000E

printed in Japan

An Introduction to the POLA Research Institute of Beauty & Culture

Disseminating Beauty and Culture to the World

Since its foundation in 1976, the POLA Research Institute of Beauty & Culture has conducted a wide range of studies regarding cosmetics in Japan, Europe and other areas from ancient times to the present day, with 'cosmetics', 'women' and 'aesthetic sense' as keywords. Our areas of research include the history of make-up, ways and customs of the past, views on feminine beauty, methods of make-up, cosmetic accessories, and a sense of beauty.

In the course of our research activities, we have collected some 6,500 items of cosmetic accessories, personal adornments, *ukiyo-e* (Japanese woodblock prints) relating to make-up, Western fashion illustrations, as well as a large amount of written material, such as rare books from the seventeenth century onwards. We have also carried out surveys into the attitude of the women of today to cosmetics since 1979.

We disseminate the results of our studies in the form of publications, websites and exhibitions, in order to deepen the understanding of cosmetic culture among the general public.